STAR, BRANCH, SPIRAL, FAN

Learn to Draw from Nature's Perfect Design Structures

YELLENA JAMES

ROCKPORT

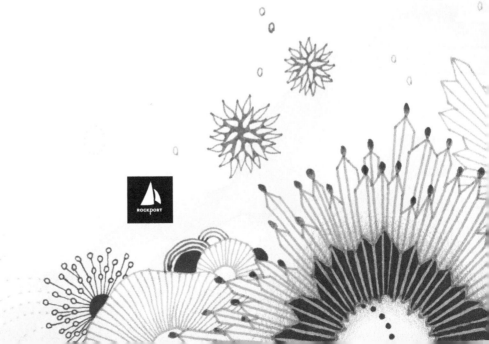

Inspiring | Educating | Creating | Entertaining

Brimming with creative inspiration, how-to projects, and useful information to enrich your everyday life, Quarto Knows is a favorite destination for those pursuing their interests and passions. Visit our site and dig deeper with our books into your area of interest: Quarto Creates, Quarto Cooks, Quarto Homes, Quarto Lives, Quarto Drives, Quarto Explores, Quarto Gifts, or Quarto Kids.

First published in the United States of America in 2017 by
Rockport Publishers, an imprint of The Quarto Group,
100 Cummings Center, Suite 265-D, Beverly, MA 01915, USA.
T (978) 282-9590 F (978) 283-2742
QuartoKnows.com

Rockport Publishers titles are also available at discount for retail, wholesale, promotional, and bulk purchase. For details, contact the Special Sales Manager by email at specialsales@quarto.com or by mail at The Quarto Group, Attn: Special Sales Manager, 100 Cummings Center, Suite 265-D, Beverly, MA 01915, USA.

ISBN: 978-1-63159-149-5

Library of Congress Cataloging-in-Publication Data
Names: James, Yellena, author.
Title: Star, branch, spiral, fan / Yellena James.
Description: Beverly : Rockport Publishers, 2017.
Identifiers: LCCN 2016032098 | ISBN 9781631591495 (paperback)
Subjects: LCSH: Drawing—Technique. | Nature in art. | Form (Aesthetics) | BISAC: ART / Subjects & Themes / Plants & Animals. | ART / Techniques / Drawing. | DESIGN / Graphic Arts / Illustration.
Classification: LCC NC730 .J265 2017 | DDC 741.2/1—dc23
LC record available at https://lccn.loc.gov/2016032098

Design and Page Layout: Debbie Berne
Cover Image: Yellena James

For my dad, who made me hats when I was little
from the leaves of elephant ears.

CONTENTS

Introduction

1

**Design Elements
and Principles** 9

Elements of Design 10
Principles of Design 13
Introducing the Four Shapes 14

2

The Star 17

Looking at Stars 17
Exercise: Drawing a Perfect
Five-Point Star 25
Exercise: Drawing a *Nearly* Perfect
Five-Point Star by Hand 25
Exercise: Drawing Star
Ornaments 26
Exercise: Drawing Star-Shaped
Creatures 27
Exercise: Drawing More Stars 29
Exercise: Drawing a Star-Centered
Sea Anemone 30
Exercise: Adding Star Forms
and Shapes 33
Exercise: Stars in Space 34
Exercise: Star Composition 37
Exercise: An Imaginary Starfish 38
Exercise: Finish the
Composition 39

3

The Branch 41

Looking at Branches 42
Branching Fractals 42
Exercise: Drawing Branching
Fractals 43
Exercise: Drawing Branches 49
Exercise: Inspired Sketches 51
Exercise: Branches in Motion 54
Exercise: Adding Branches 57
Exercise: Balancing Your Composition 59
Exercise: Branching Leaves 61
Exercise: Finish the Composition 63
Exercise: Negative Space 65

4

The Spiral 67

Types of Spirals 68
Looking at Spirals 69
Exercise: How to Draw a Spiral 70
Exercise: Abstract Pinwheels 77
Exercise: Drawing a Spiral Shell 80
Exercise: Adding Color 82
Exercise: Pattern Inspiration 83
Exercise: Floral Spiral Ornaments 85
Exercise: Adding Spirals to Jellyfish 87
Exercise: Finish the Composition 88

5

The Fan 91

Looking at Fans 91
Exercise: Examining Depth 97
Exercise: Evolving the Fan Shape 98
Exercise: Drawing Fan-Shaped
Plants 101
Exercise: Creating a Fan Motif
Pattern 103
Exercise: Creating a Fan-Shape
Repeating Pattern 104
Exercise: Adding Fan Shapes 108
Exercise: Drawing Betta Fish 110
Exercise: Finish the
Composition 113

6

Putting It All Together 115

Resources 126
Acknowledgments 126
About the Author 128

INTRODUCTION

Nature is a brilliant designer. She combines form and function perfectly within her designs in an ever-evolving display of balance and symbiotic forms.

In this book, we'll take a look at four of the most magical shapes in nature: the star, the branch, the spiral, and the fan. They're magical because they appear and work so well in so many places. With pens, pencils, or brushes in hand, we'll use these fundamental shapes to create our own natural forms and, using core elements of design and nature, we'll bring our creations to life.

This book is more sketchbook than textbook. It's meant to inform, but my primary focus is to encourage you to explore nature's magical designs in adventurous, fun, and colorful ways. The goal is to inspire you to create and learn through the process of creating.

We'll start by looking at the shapes and examining where they can be found in nature. Next, we'll draw them several different ways to familiarize ourselves with their fundamental constructs. And we'll learn how to apply these shapes within the principles of design.

The last chapter is a collaborative artistic exploration. I've included guided drawings of the shapes within the book, providing backgrounds and faint outlines of compositions that you are encouraged to draw over and expand upon. As the chapter progresses, I add less and less to the pages, so you can develop compositions of your own invention.

The exercises within these pages can be completed by people of all skill levels: fans of art who enjoy taking part in the process, students looking for ways to sharpen their skills, and advanced artists interested in expanding their range in an organic way. By going through the lessons in this book, you'll gain a better understanding of how to draw from—and draw inspiration from—nature's magical designs.

Yellena James

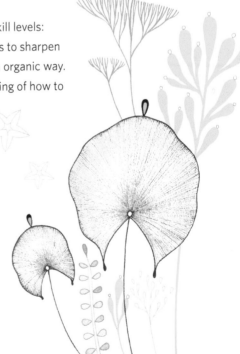

1
DESIGN ELEMENTS AND PRINCIPLES

There are seven elements of design, as well as seven principles of design.
The following table summarizes them at a glance.

Elements of Design	Principles of Design
1. Line	1. Pattern
2. Shape	2. Contrast
3. Texture	3. Emphasis
4. Space	4. Balance
5. Value	5. Scale
6. Color	6. Harmony or unity
7. Size	7. Rhythm or movement

Using these elements and principles effectively will help elevate your artwork. It's good to keep them in mind when approaching any new piece, and they come up in almost every exercise in this book. Use them often enough and they'll become second nature: You'll begin applying them without the need to identify them.

◀ *Crush.* Pen and watercolor on panel.

Elements of Design

Let's explore the importance of each design element individually.

LINE

Line is used in artwork to establish forms (3-D elements) and shapes (2-D elements), to show depth or to establish movement in a piece. Line can be straight, wavy, dotted, broken, thick or thin, bold, parallel, perpendicular, horizontal, vertical, or curved. Curiously, there are no lines in nature. Everything we see around us that might look like a line—such as a hair or a thread—actually has a *form*.

SHAPE

Shape can be geometric or organic. *Geometric shapes* are made using uniform measurements and perfect math. *Organic shapes* are more free form and unpredictable. Familiar shapes include rectangles, squares, triangles, and ellipses, but in this book, we'll focus on the organic natural shapes of stars, branches, spirals, and fans. You can establish contrast in your designs by using geometric versus organic shapes. Or you can establish unity by using only geometric shapes or only organic shapes.

TEXTURE

Texture can be visual or physical. *Visual texture* is implied by the use of repeating lines, shapes, or shading. *Physical texture*, or actual texture, can be created using thick paint, fibers, and anything else that can be felt. Cracked paint can imply dryness, wear, or fragility. Smooth areas can project calmness. Using different textures together can give a piece contrast, rhythm, etc., and can help define the overall feeling of a design.

SPACE

Space is the area *around* or *within* objects. There's negative space, which relates to the space between objects, and positive space, which is the space occupied by objects. These are dominant elements in design, something that you notice from far away.

VALUE

Value relates to the lightness and darkness of colors—the greater the difference in color values, the greater the contrast of a piece.

COLOR

Used to establish the feeling of a piece, each color has a different value and saturation, which refers to the color's intensity. Colors can invoke mood or emotion, create contrast, and add emphasis. They are a very powerful element of design.

SIZE

Size refers to the size of one section or element of a design versus that of another section or element. It can be used to create contrast, emphasis, depth, and more. The overall size of a piece can also be used to make a statement or convey meaning.

Composition using star, fan, branch, and spiral shapes ▶

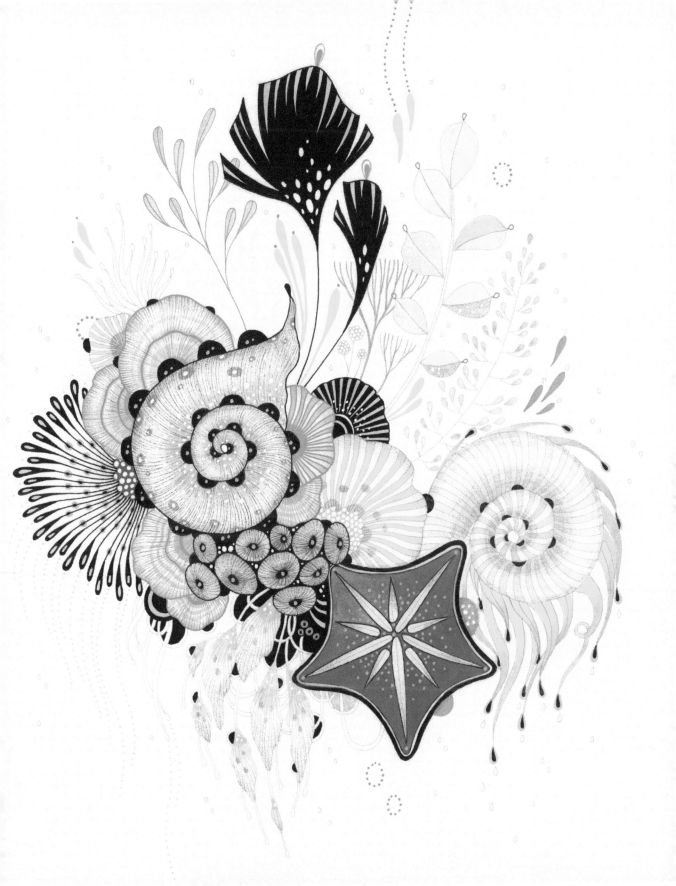

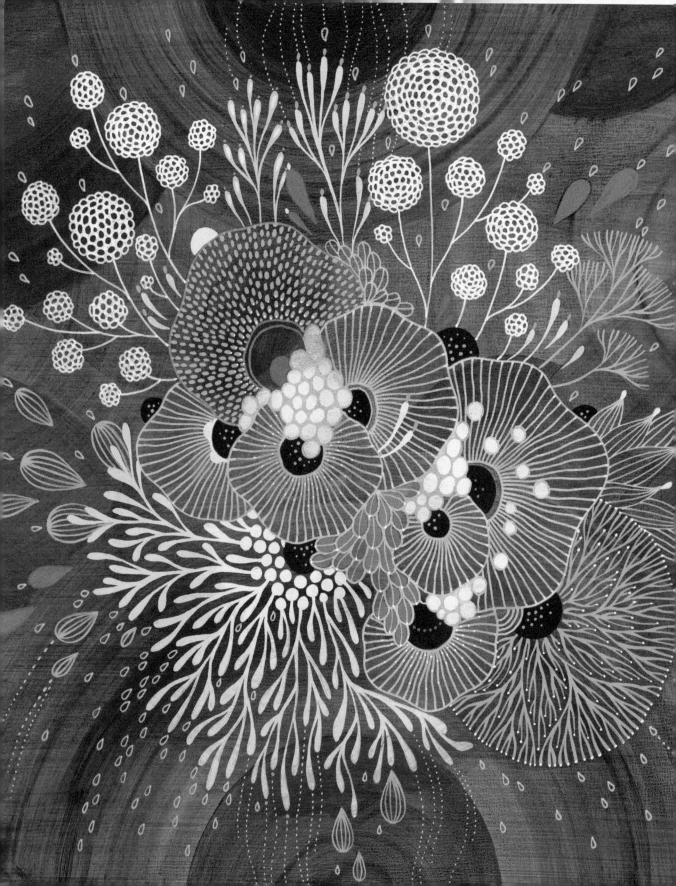

Principles of Design

Now, we'll explore the seven principles of design one by one.

PATTERN

Achieved by repeating a color, shape, or any other element in the artwork, pattern can help with the cohesiveness of a piece.

CONTRAST

Contrast refers to differences or juxtapositions among the elements of a piece. It can be achieved in various ways: light versus dark elements; geometric versus organic shapes; thick lines versus thin lines; and big objects versus small objects.

EMPHASIS

In a composition, emphasis establishes a focal point that grabs attention. It can be achieved many ways, including with contrasting colors, shapes, or sizes.

BALANCE

Balance refers to the visual weight distribution in a piece. This can refer to balancing colors, shapes, or elements within the artwork.

SCALE

Scale helps establish the depth of a piece, where closer elements appear larger, for instance. Scale can also establish emphasis or dominance of certain elements. Conversely, the use of same-size objects can establish unity.

HARMONY OR UNITY

This principle refers to the way things are positioned within the artwork to give the viewer a sense of consistency. Harmony emerges when all parts fit well together and complement each other.

RHYTHM OR MOVEMENT

Rhythm or movement is created by how elements are arranged within an artwork, guiding the eye.

◄ *Seedling.* Acrylic on panel. In this radial composition, the elements, including branches and fans, are arranged bursting from the center point.

INTRODUCING THE FOUR SHAPES

The four shapes that inspired this book—star, branch, spiral, and fan—are found throughout nature's creations, from microorganisms to entire galaxies. Following is a brief introduction to each shape, along with a highly abbreviated list of where they can be found and how they are useful in design. (A complete list would be vast!) In the chapters that follow, we'll look at each shape more closely and get hands-on with different design applications.

Star

A star has five or more points that radiate from a common center. As with all the shapes in this book, the star can be expressed as a geometric shape or as an organic, natural shape. The center can be a single point or spread out, depending on the application.

Where to Find Stars in Nature

- Crystals
- Flowers
- Fruits
- Sea creatures
- Seedpods
- Snowflakes
- Vegetables

How Stars Are Useful in Design

Stars are great for creating emphasis, exaltation, and contrast and for balancing elements within a composition.

Branch

A branch comprises a main stem or axis with one or more offshoots. The branch allows nature to reach out and expand into empty spaces, and it can be useful in design for the same purpose. It's often used for transport, connecting the main stem with its extremities. Branch shapes can be totally random or follow strict measurements and ratios.

Where to Find Branches in Nature

- Corals
- Lightning
- Nervous system
- Rivers
- Roots
- Trees and other plants
- Veins

How Branches Are Useful in Design

Branching can connect elements of a design, imply growth, create pattern, contrast, and rhythm, and help guide a viewer's eyes through a piece.

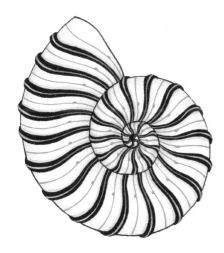

Spiral

A spiral is a gradually widening curve. Spirals represent the basis for all growth and energy. Energy is strongest near the center of a spiral, as seen in storm formations, such as hurricanes and tornadoes. It is also a very efficient shape. Many plants develop branches, leaves, and flower buds around their stems in a spiral form so that each leaf gets maximum sun exposure.

Where to Find Spirals in Nature

- DNA
- Ferns
- Fingerprints
- Galaxies
- Pinecones
- Seed patterns
- Shells
- Storm patterns

How Spirals Are Useful in Design

Spirals can be used to evoke life force, growth, and energy flow or to create depth and movement within a piece.

Fan

A fan is a series of repeating lines or shapes that meet at one end. It is a symbol of expansion. In nature, it's a streamlined shape that creates drag and disperses the forces applied to it. The juxtaposition between its focal point—or *vanishing point*—and its expanded edge make it a very useful shape in art and design.

Where to Find Fans in Nature

- Birds' wings and tails
- Feathers
- Fish fins
- Fungi
- Gingko leaves
- Palm fronds
- Shells

How Fans Are Useful in Design

Fans are great for creating emphasis or scale, establishing focal points, or developing movement and direction in a piece.

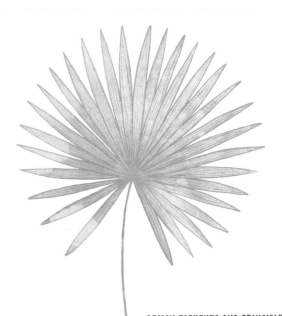

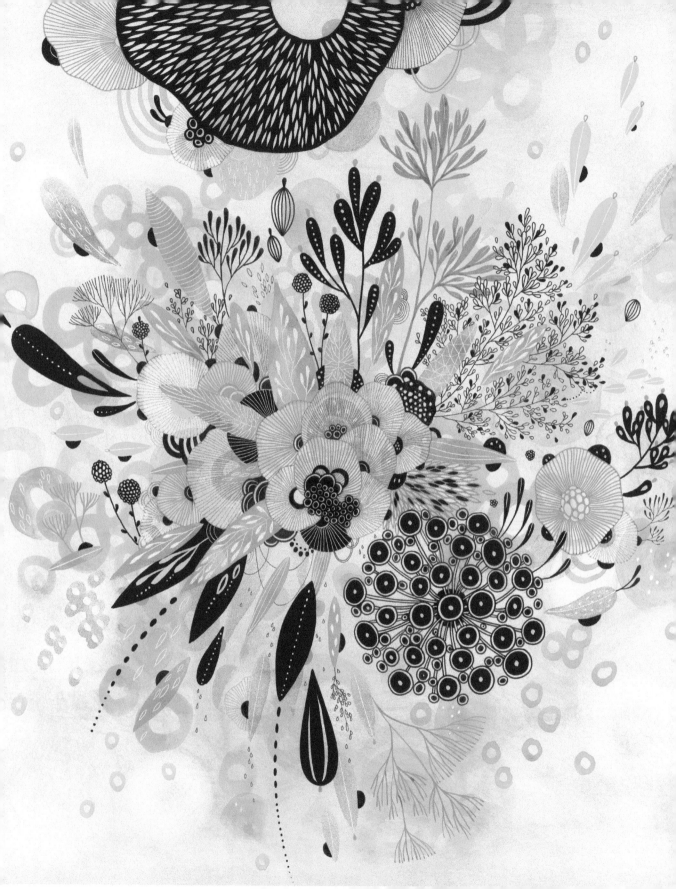

2
THE STAR

You will discover many examples of the star shape throughout nature. Snowflakes contain endless varieties of six-fold symmetrical stars. Stars appear in the centers of many fruits and flowers, as well as in starfish, sand dollars, and other creatures of the sea. We see them in the refracted light from distant galaxies and the seedpods of the sweet gum tree. Stars are all around us.

In this chapter, we start by looking at the various forms of stars and explore some of the many ways they have been incorporated into nature's grand design. We'll use these shapes to create interesting compositions, as well as intriguing elements within those compositions.

Looking at Stars

On the following pages are many illustrations of stars found in nature. There are star-shaped creatures that live underwater, star-shaped plants and flowers, stars found in fruits and seeds, geometric stars, and star-shaped formations found in crystals and minerals. Even water can form stars as it freezes. There are so many stars, in fact, that no two snowflakes are identical in shape and size.

◀ *Scatter.* Pen and watercolor on panel. A star may not be the first thing you think of when you look at this composition, but it is based on a star's design. All elements radiate from the center. Stars can influence design in subtle ways.

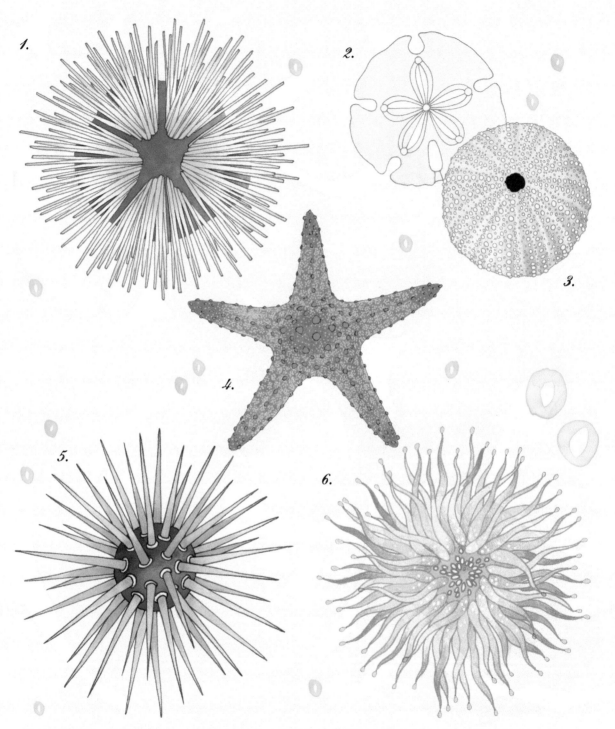

*The sea abounds with starbursts in myriad forms. 1. Blue tuxedo urchin 2. Sand dollar 3. Sea urchin 4. Starfish
5. Hitchhiker urchin 6. Sea anemone*

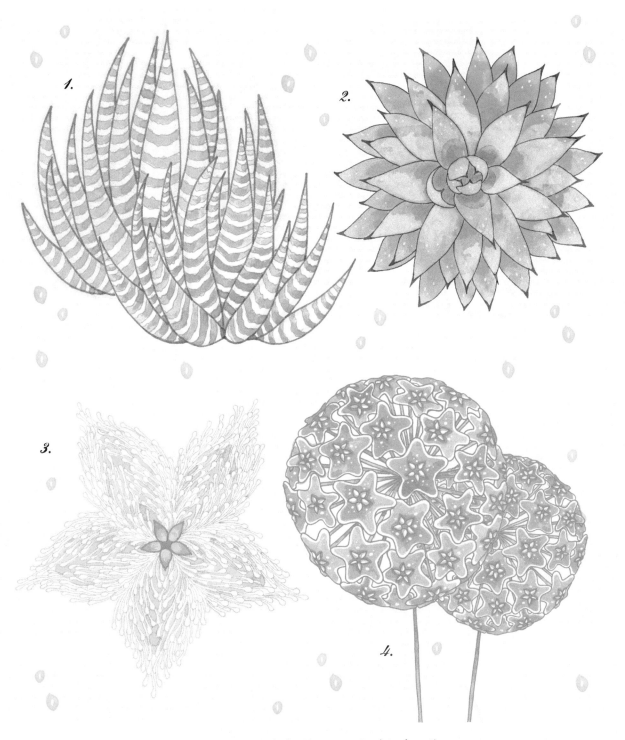

The petal- and leaf-growth patterns of many flowers and other plants are natural star formations.
1. Haworthia *2. Blue agave* 3. Stapelia glanduliflora 4. Hoya kerrii

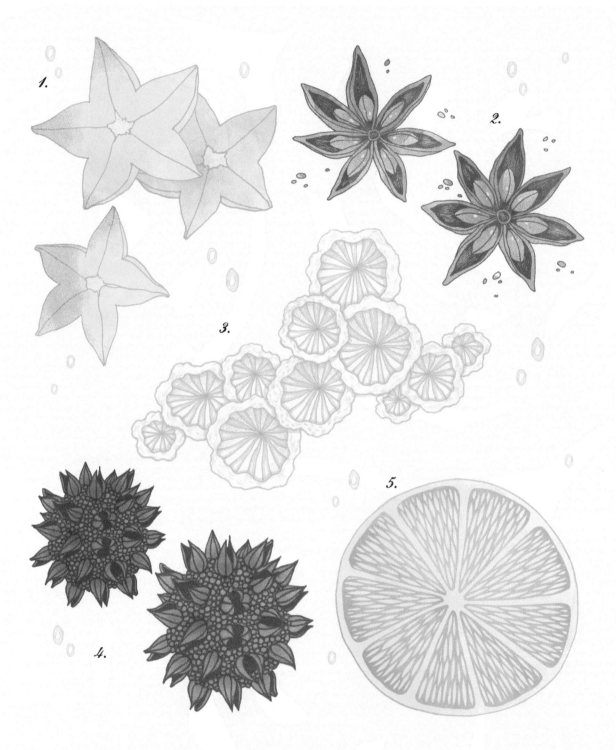

Slice a fruit or seedpod in half and you might find a star inside. 1. Star fruit 2. Anise 3. Split gill 4. Sweet gum tree pods 5. Orange

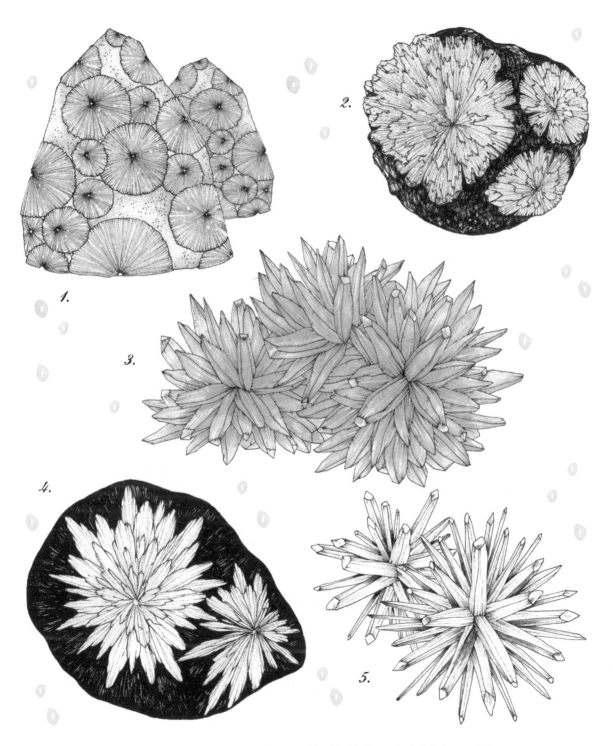

Rock crystals grow in complex, three-dimensional star forms. 1. Wavellite 2. Cavansite 3. Cobaltoan calcite
4. Chrysanthemum 5. Quartz

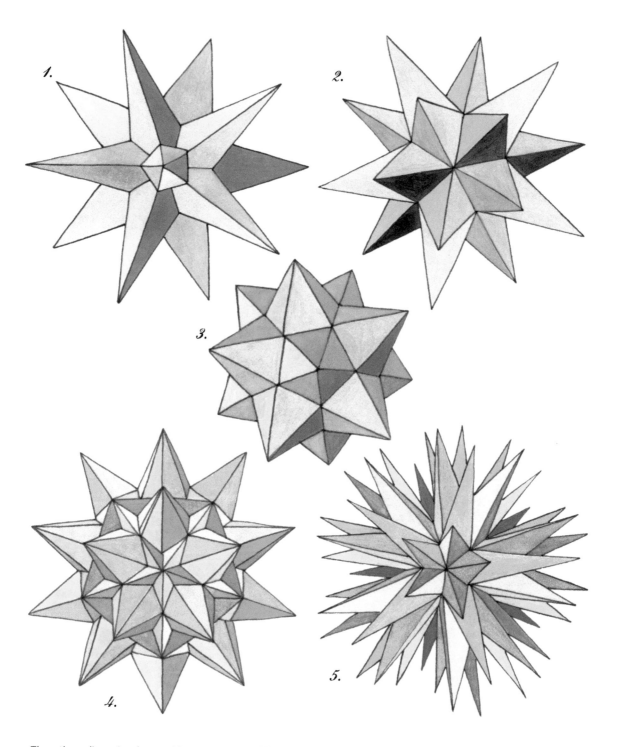

These three-dimensional geometric star structures all have stellar names. 1. Great icosahedron 2. Great stellated dodecahedron 3. Small stellated dodecahedron 4. Seventh stellation of the icosidodecahedron 5. Final stellation of the icosahedron

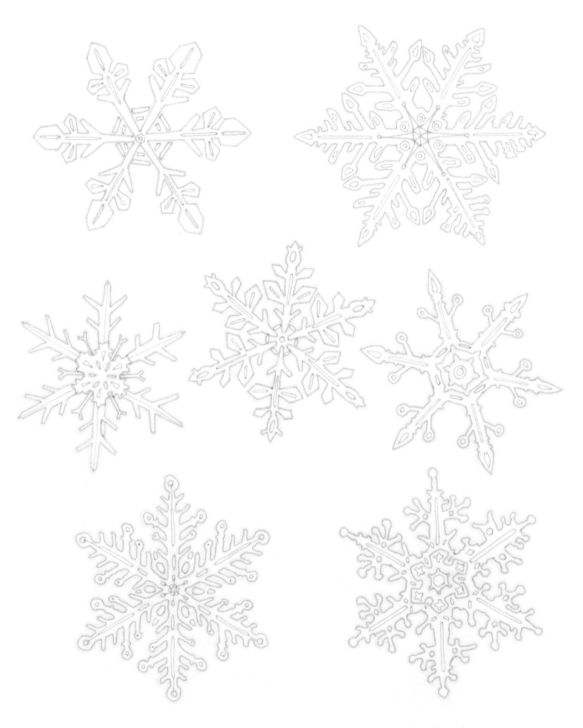

All snowflakes begin with a hexagonal ice crystal. An infinite number of six-armed shapes have formed on those miniscule centers.

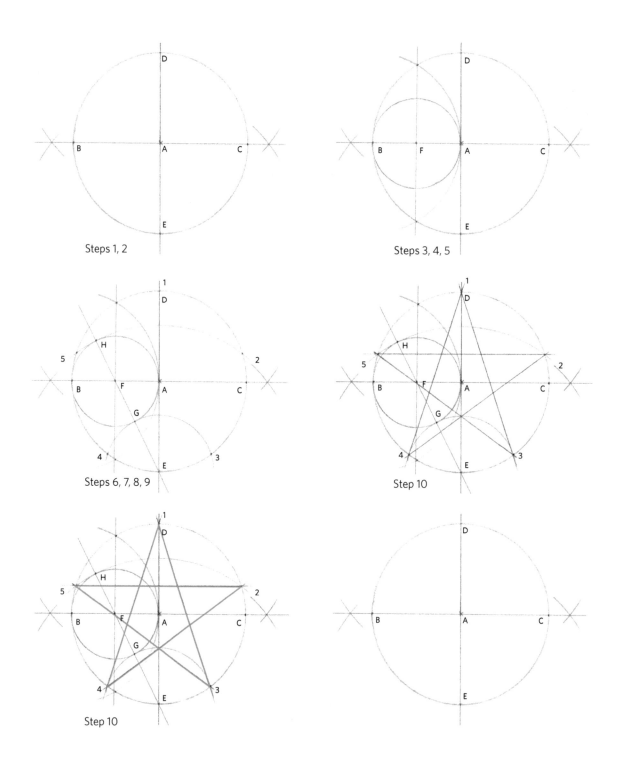

Steps 1, 2

Steps 3, 4, 5

Steps 6, 7, 8, 9

Step 10

Step 10

Exercise: Drawing a Perfect Five-Point Star

Drawing a perfect star requires a number of steps, a ruler, and a compass. Working through the steps will help you appreciate the beauty and complexity of this seemingly simple five-pointed shape. In these diagrams, I set up the last one like the first so you can use it as a starting point. Get out your compass and create a perfect five-point star of your own.

1. Draw a circle with a compass. Now draw a straight vertical line through the center of the circle. Mark the points E, A, and D, as shown.

2. Open your compass wide and draw a mark outside both sides of the circle from points E and D. Connect these marks to get a perpendicular line running horizontally through the center. Mark the points B and C.

3. With the compass on point B, set it to the size of the circle's radius. Draw a semicircle, with point A at the center of the arc.

4. Draw a vertical line through the points where the semicircle intersects the circle. Mark point F in the middle.

5. With the compass on point F, draw a circle that touches points A and B.

6. Using a ruler, draw a straight line from point E through point F, to establish points G and H.

7. With the compass on point E, draw a semicircle that passes through point G and intersects the main circle at two points.

8. With the compass still on point E, open it and draw a semicircle that passes through point H. With a ruler, draw a line that passes through points H and E.

9. Starting at the top of the circle, mark five points of intersection around its circumference: 1, 2, 3, 4, and 5, as shown.

10. Using the ruler, connect points 1 and 3; 3 and 5; 5 and 2; 2 and 4; and 4 and 1. Voilà, you've drawn a perfect five-point star.

Exercise: Drawing a *Nearly* Perfect Five-Point Star by Hand

Let's try it now without the compass and ruler.

1. On a separate piece of paper, draw a circle and divide it into four equal parts with a horizontal and a vertical line.

2. Divide the top half of the circle *horizontally* into three equal parts. The center horizontal line will give you points 2 and 5.

3. Draw an X through the center to divide the quadrants of the circle in half. Mark points 3 and 4 just under the intersecting lines as shown.

4. Connect the points for a five-point star that is *nearly* perfect.

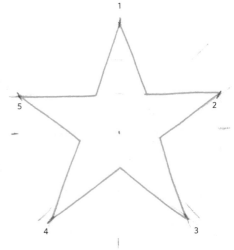

These simple shapes give you a starting point for thinking about stars. A star has at least five points, but, after that, you can add as many as you like or overlay two stars with different numbers of points.

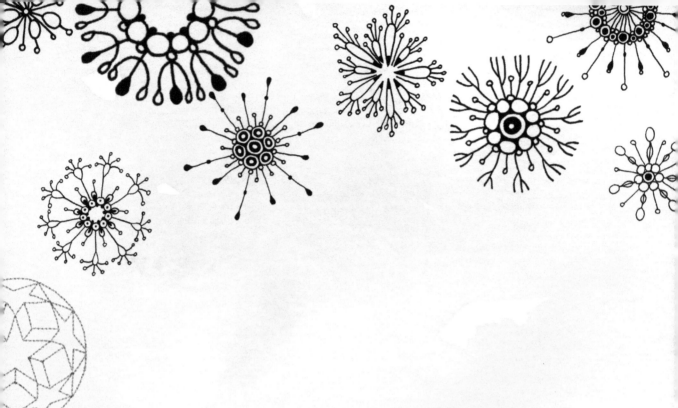

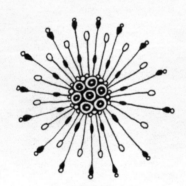

Exercise: Drawing Star Ornaments

Draw ornaments and motifs based on a star shape. Use a pencil to sketch them, or—if you're feeling confident—draw them with a pen. Try working with different sizes of pens to add emphasis.

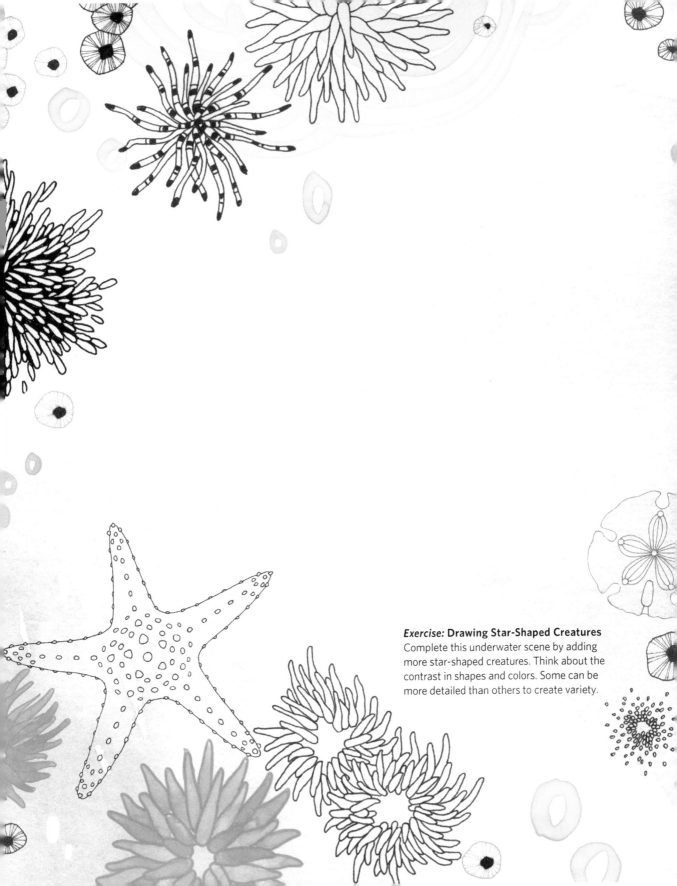

***Exercise:* Drawing Star-Shaped Creatures**
Complete this underwater scene by adding
more star-shaped creatures. Think about the
contrast in shapes and colors. Some can be
more detailed than others to create variety.

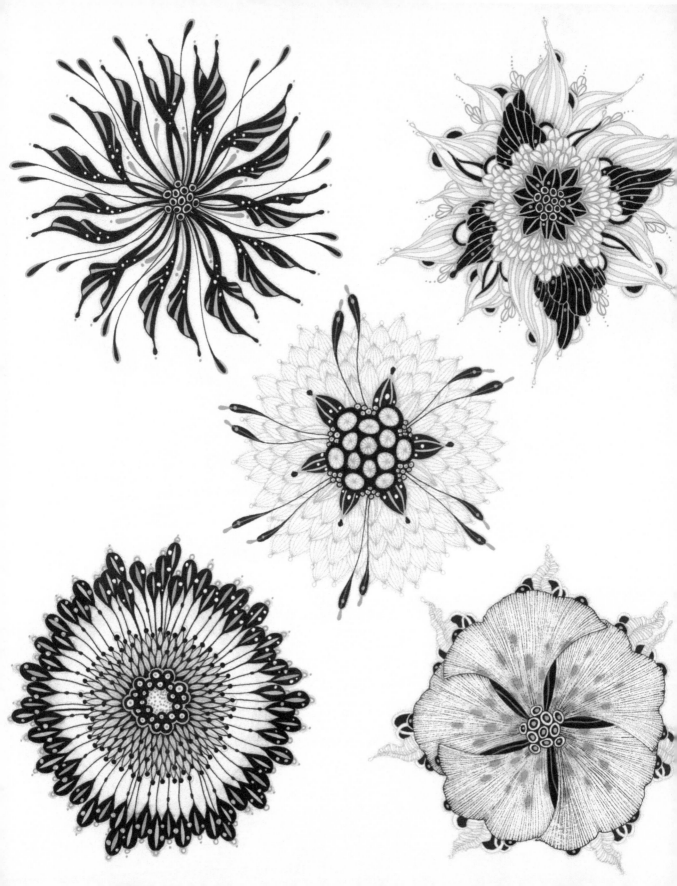

Exercise: **Drawing More Stars**

Use the star as an inspiration to draw some ornamental shapes.
Sketch the ornaments with pencil first. Then go over them with
pen and color once you are happy with your drawing.

Exercise: Drawing a Star-Centered Sea Anemone

In this exercise, you will learn how to use a star shape to draw a sea anemone. Work on the opposite page, following these instructions.

1. Using a light pencil, draw three concentric fluid shapes on the opposite page. Then draw line segments radiating from a center circle. Start defining the elements with a pen using the pencil drawing as a guide.

2. To further define the form, add more shapes in a variety of sizes, while still paying attention to the pencil-drawn guide.

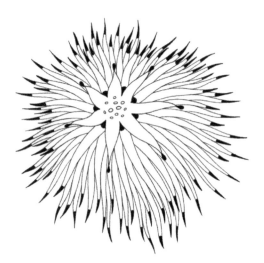

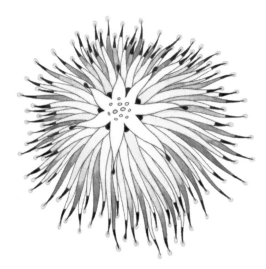

3. Erase the pencil marks and add details to the shape. Think about using a darker color for accents.

4. Finally, add color to your drawing. Using lighter colors on top and darker colors on the bottom will give your drawing a three-dimensional look.

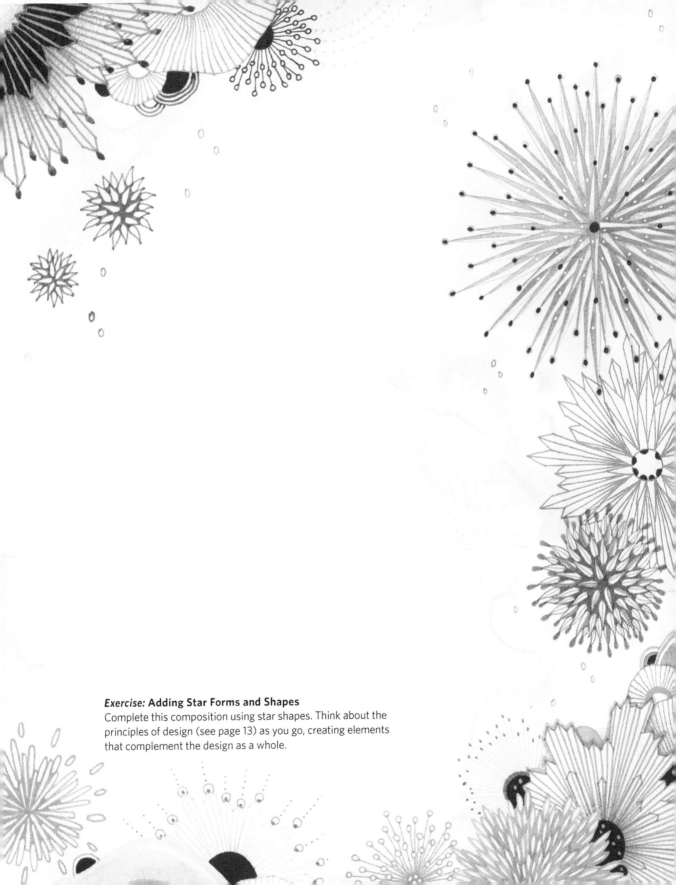

***Exercise:* Adding Star Forms and Shapes**
Complete this composition using star shapes. Think about the
principles of design (see page 13) as you go, creating elements
that complement the design as a whole.

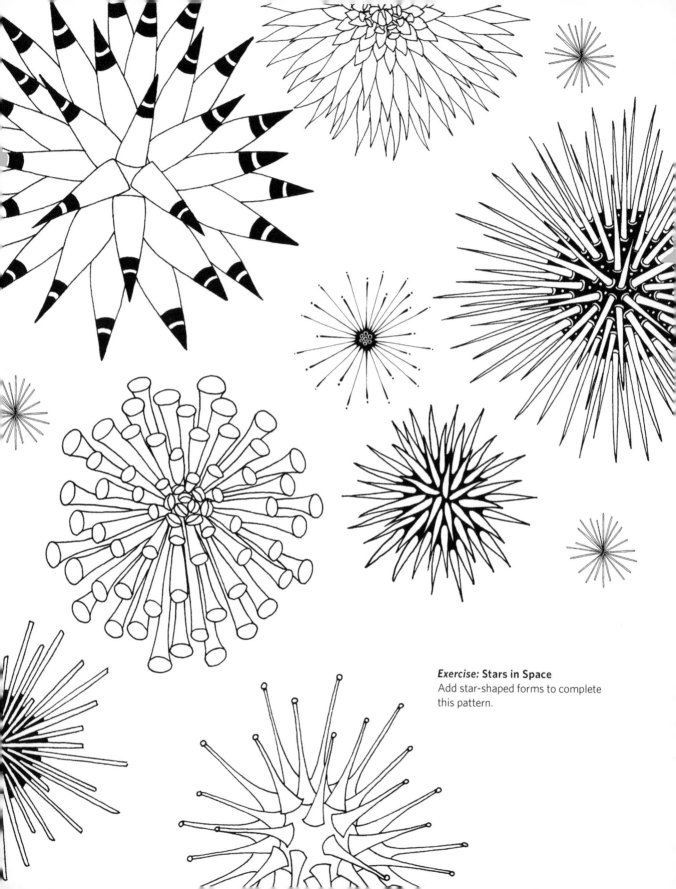

Exercise: Stars in Space
Add star-shaped forms to complete
this pattern.

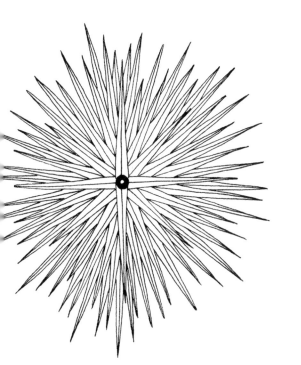

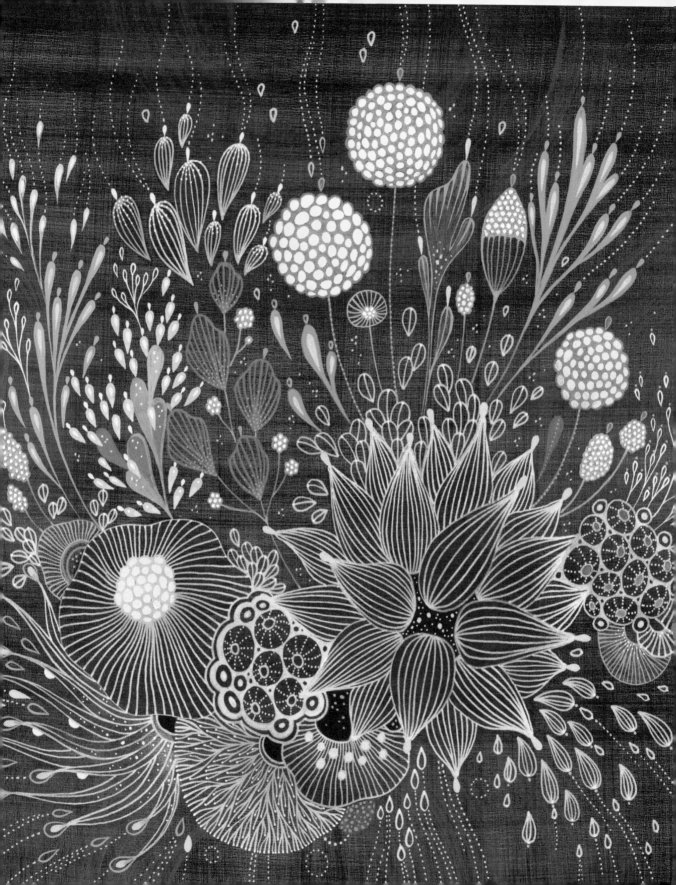

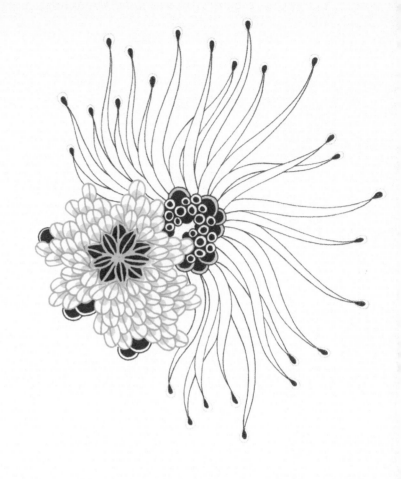

Exercise: Star Composition

Finish this drawing by adding star shapes. Keeping the balance
of form and color in mind, try to create a composition that
connects the two illustrative elements on the page.

◄ *Hint.* Acrylic on panel. This composition uses
a star-shape element as a focal point.

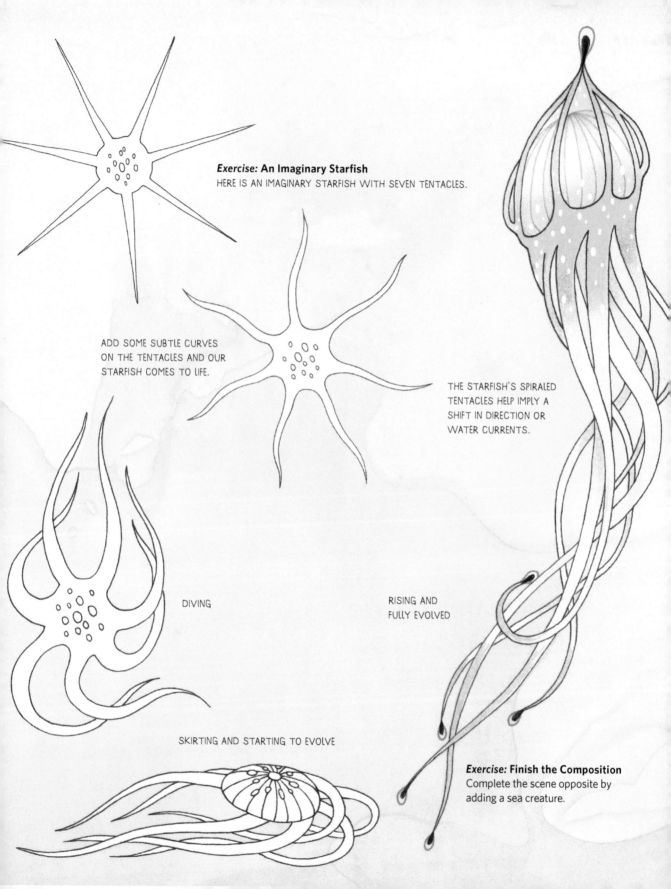

Exercise: **An Imaginary Starfish**
HERE IS AN IMAGINARY STARFISH WITH SEVEN TENTACLES.

ADD SOME SUBTLE CURVES
ON THE TENTACLES AND OUR
STARFISH COMES TO LIFE.

THE STARFISH'S SPIRALED
TENTACLES HELP IMPLY A
SHIFT IN DIRECTION OR
WATER CURRENTS.

DIVING

RISING AND
FULLY EVOLVED

SKIRTING AND STARTING TO EVOLVE

Exercise: **Finish the Composition**
Complete the scene opposite by
adding a sea creature.

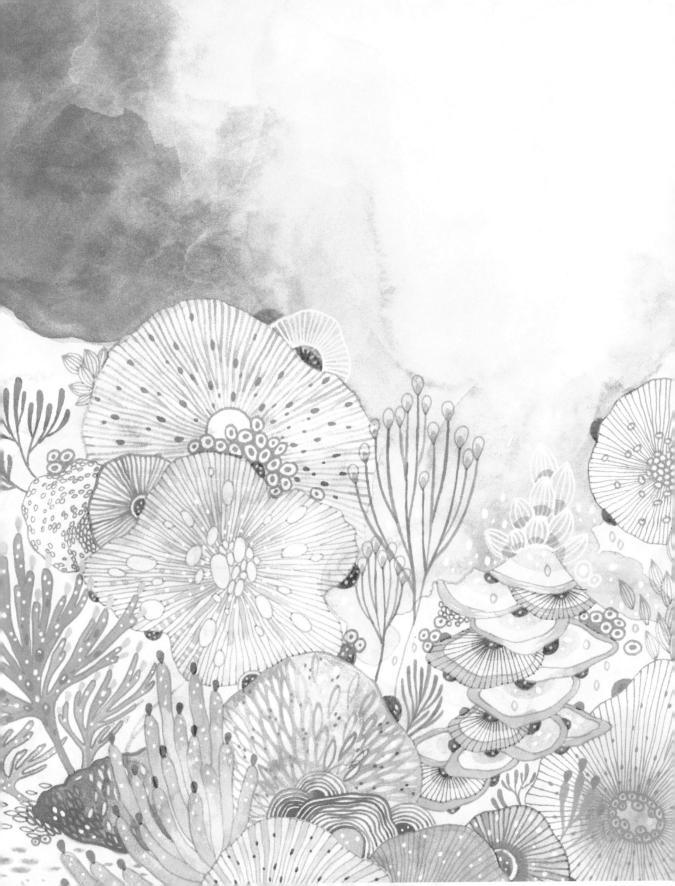

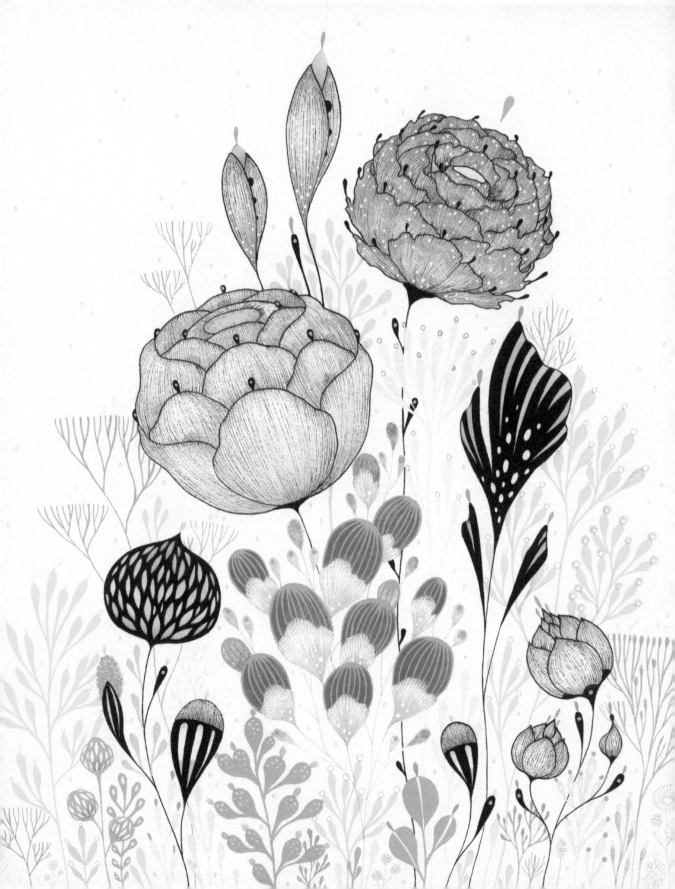

3

THE BRANCH

Branching is nature's way of moving energy or matter from a single point to a wider area and vice versa. Consider the way a tree sprouts up and grows outward, reaching in all directions to provide each of its leaves with the maximum amount of light. A tree's root system also branches, spreading out to reach water and nutrients and provide the greatest amount of support for the upper part of the tree. All of a tree's parts are connected through branching.

As a tree's branches and roots feel their way into empty spaces, they're apt to follow specific patterns—it's in their DNA. A maple tree always branches like a maple tree and a spruce like a spruce. The same is true for the branching seen in other living things: the nerves and veins in our bodies, the mycelia in fungi, and the lines in a dragonfly's wings.

But even when no DNA is involved, as in the case of lightning patterns, river systems, or the built-upon structures of salt crystals, branching in nature often displays patterns with similar ratios of angles and distances. The phenomenon of infinitely repeating patterns is known as *fractal design*, and it is one of the ways in which nature creates balance within chaos.

Nature uses branching to gather and distribute energy and materials throughout open spaces in an efficient manner. Similarly, we can use branching to distribute color, emphasis, and flow throughout the designs we create.

◀ *Comely.* Pen and gouache on paper. Composition containing a variety of branches.

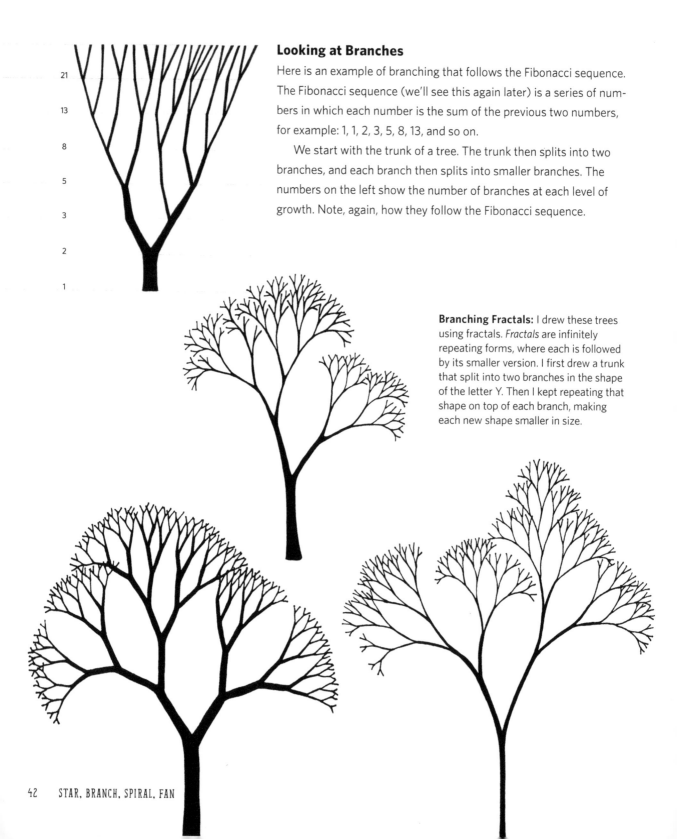

Looking at Branches

Here is an example of branching that follows the Fibonacci sequence. The Fibonacci sequence (we'll see this again later) is a series of numbers in which each number is the sum of the previous two numbers, for example: 1, 1, 2, 3, 5, 8, 13, and so on.

We start with the trunk of a tree. The trunk then splits into two branches, and each branch then splits into smaller branches. The numbers on the left show the number of branches at each level of growth. Note, again, how they follow the Fibonacci sequence.

Branching Fractals: I drew these trees using fractals. *Fractals* are infinitely repeating forms, where each is followed by its smaller version. I first drew a trunk that split into two branches in the shape of the letter Y. Then I kept repeating that shape on top of each branch, making each new shape smaller in size.

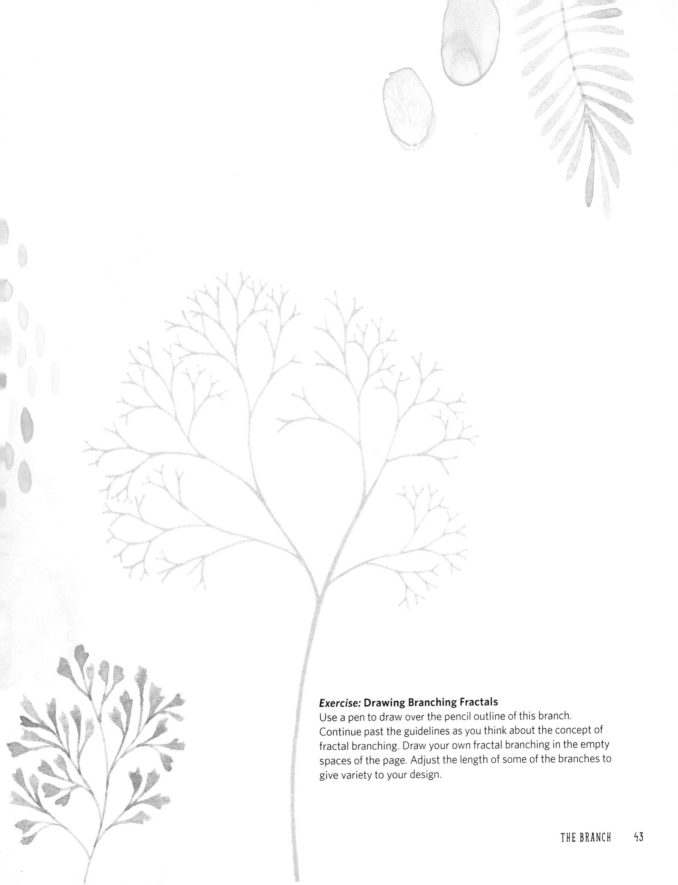

Exercise: Drawing Branching Fractals
Use a pen to draw over the pencil outline of this branch.
Continue past the guidelines as you think about the concept of
fractal branching. Draw your own fractal branching in the empty
spaces of the page. Adjust the length of some of the branches to
give variety to your design.

1. Chervil 2. Fern 3. Dill 4. Rosemary

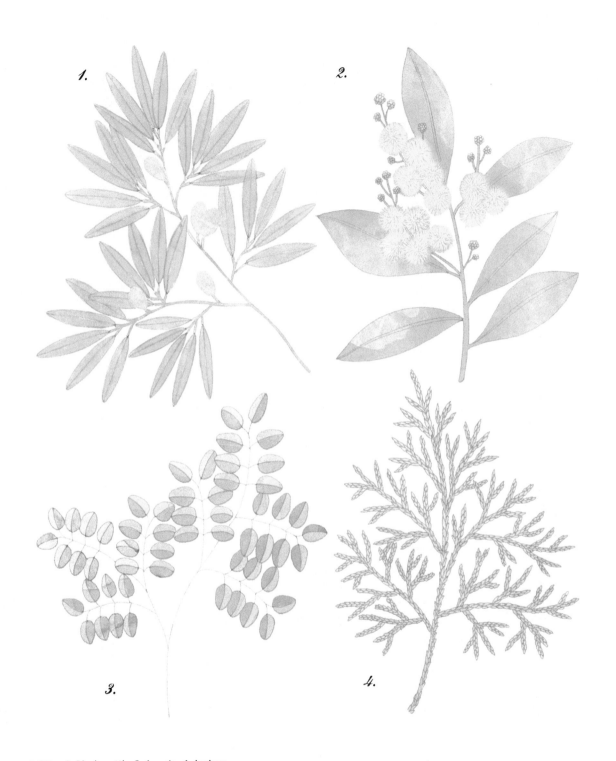

1. *Olive* 2. *Black wattle* 3. *Acacia* 4. *Juniper*

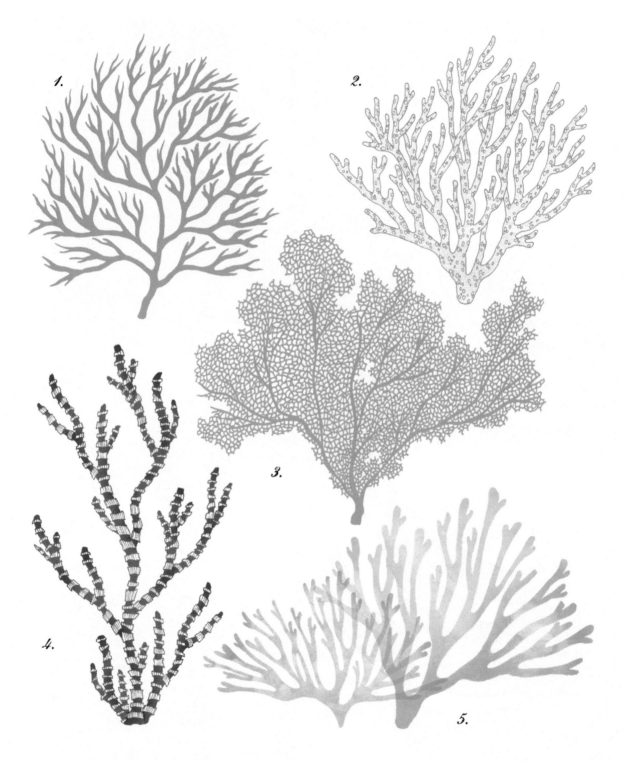

1. Corallium rubrum, *2. Sea rod 3. Sea fan 4.* Isis hippuris *5. Bladder wrack*

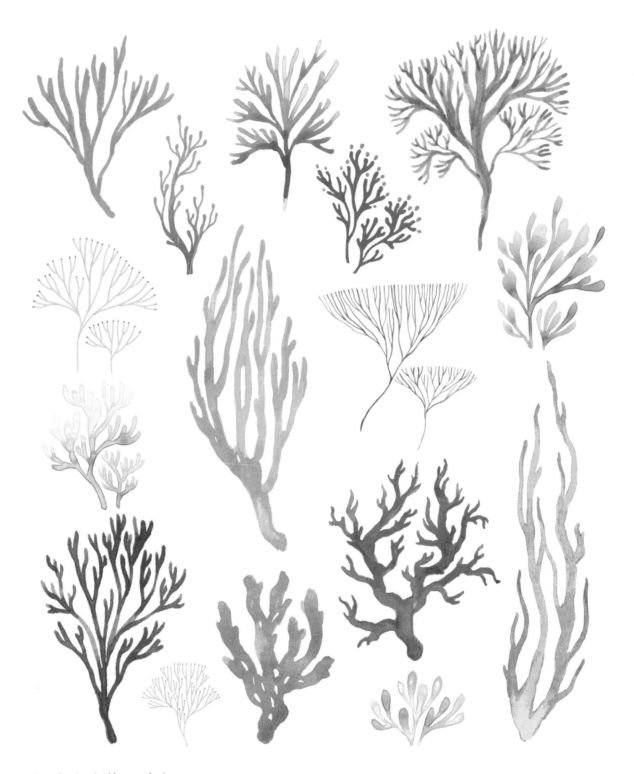

Branches inspired by sea plants

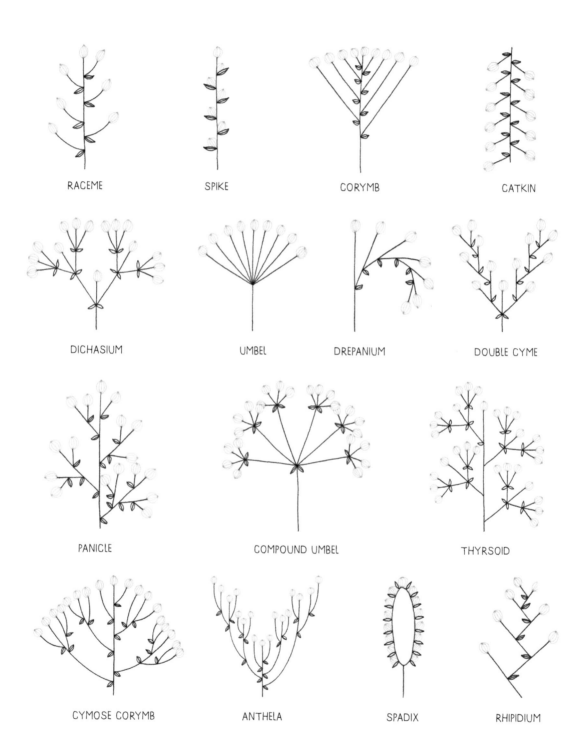

RACEME

SPIKE

CORYMB

CATKIN

DICHASIUM

UMBEL

DREPANIUM

DOUBLE CYME

PANICLE

COMPOUND UMBEL

THYRSOID

CYMOSE CORYMB

ANTHELA

SPADIX

RHIPIDIUM

Inflorescence

Some plants have only one flower to a single stem; others have multiple flowers. The arrangement of flowers on a stem and branches is called inflorescence, which can be simple or complex. Sometimes clusters of flowers are so compact they appear as a single flower.

Exercise: Drawing Branches

Pick out a few types of inflorescence from the opposite page and draw branches of your own. Sketch them lightly with a pencil, adding leaves and flowers. Once you're finished, go over it with a pen and then add color.

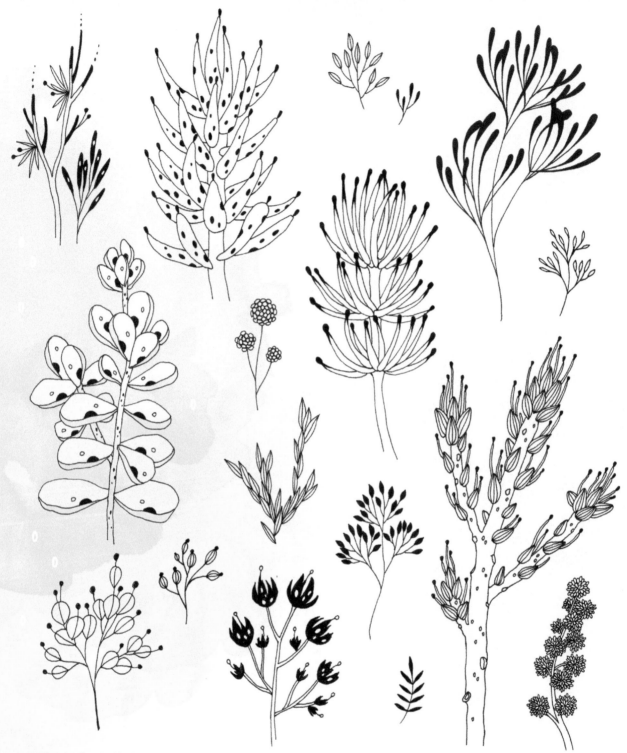

Sketches inspired by branches found in nature

Exercise: Inspired Sketches

Take a walk outside and collect some tree branches or plants. Choose a variety, if you can, looking for unique branching structures. Look at the branches closely from all sides until you find the most interesting angle. Don't worry about trying to draw them realistically. Instead, make modifications or add details of your own. Sketch with a pencil or your favorite pen. Once you've spent time what you've collected, try drawing some branches without visual references to see what you come up with.

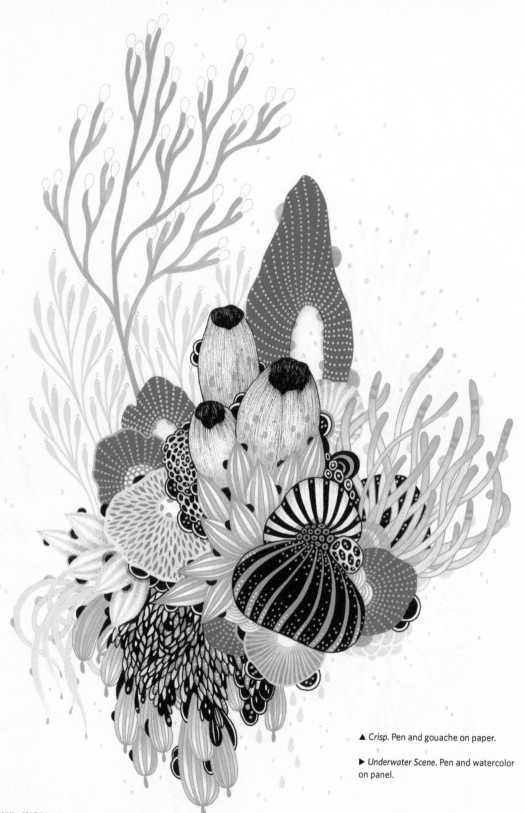

▲ *Crisp*. Pen and gouache on paper.

▶ *Underwater Scene*. Pen and watercolor on panel.

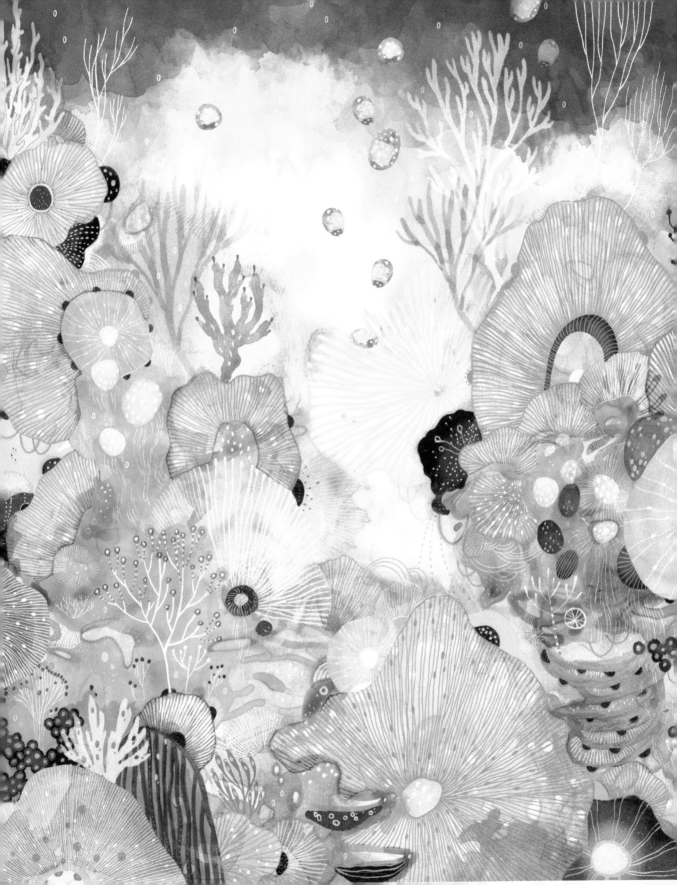

Exercise: Branches in Motion

In this exercise, we'll study branches in motion. Work on the opposite page, following these instructions.

1. Draw a branch in a very simple form, so that all the small branches leading off the main stem are fully visible. In this step, think only about the arrangement of the branches.

2. Draw the same branch but slightly curved, in a more relaxed state. By adding subtle curves, the branch looks more organic and natural.

3. Imagine there's a slight breeze blowing and all the small branches are following the same curve. Adding movement to your branch makes it come to life. Work in black and white or add color.

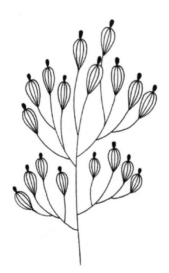

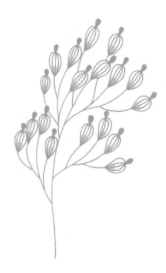

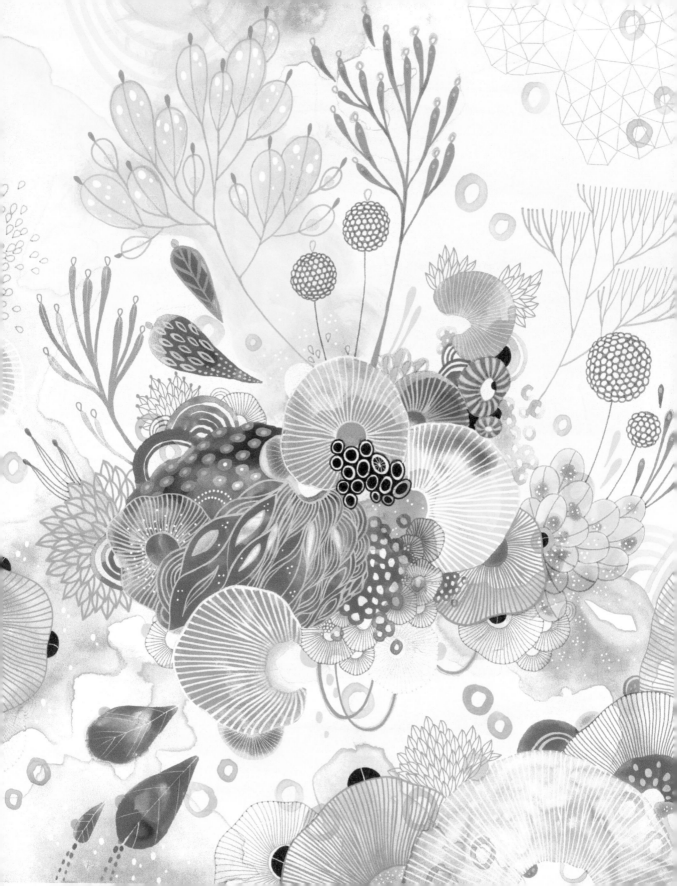

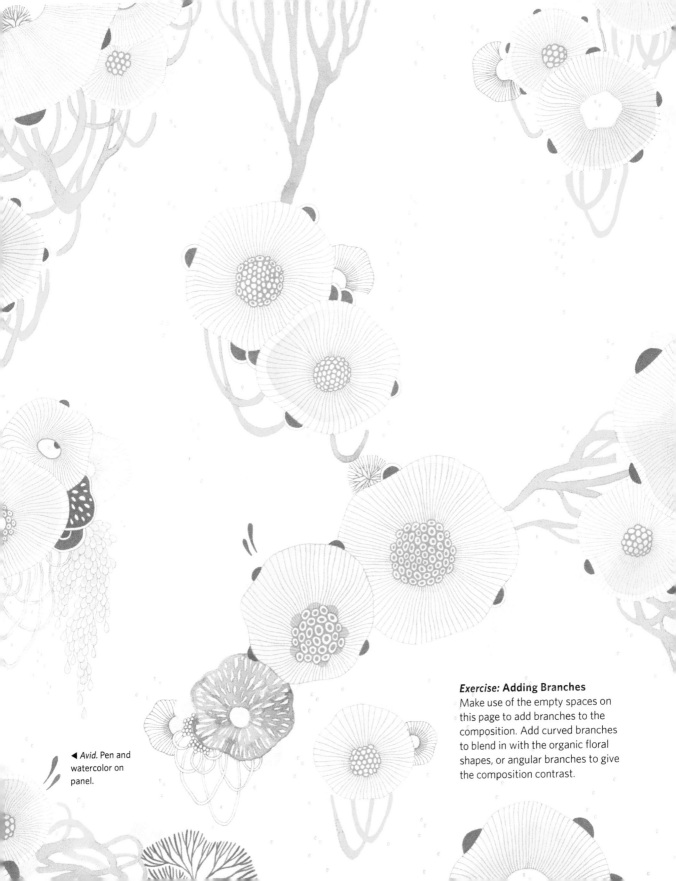

◀ *Avid.* Pen and watercolor on panel.

***Exercise:* Adding Branches**
Make use of the empty spaces on this page to add branches to the composition. Add curved branches to blend in with the organic floral shapes, or angular branches to give the composition contrast.

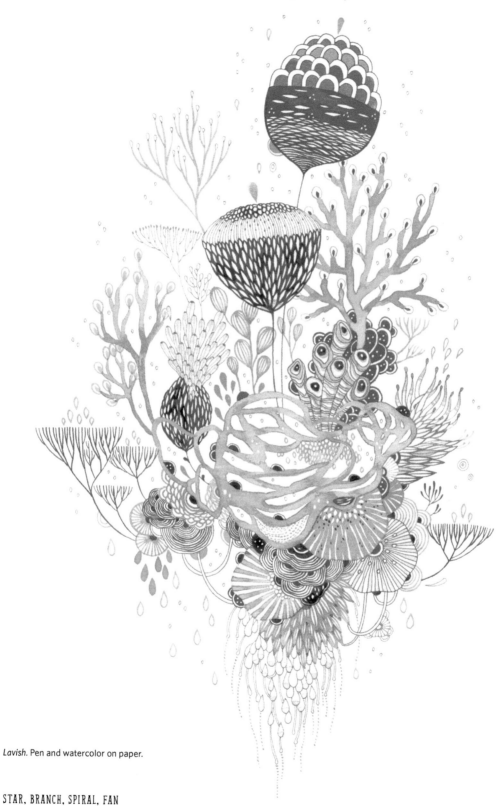

Lavish. Pen and watercolor on paper.

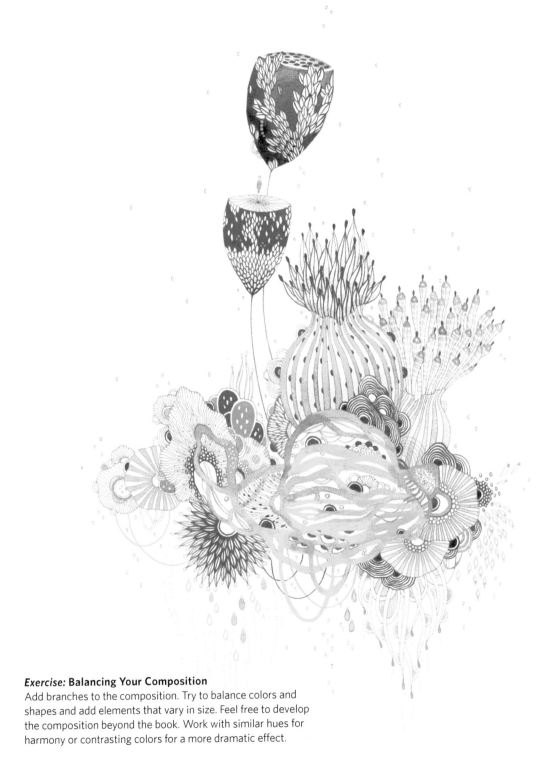

***Exercise:* Balancing Your Composition**
Add branches to the composition. Try to balance colors and
shapes and add elements that vary in size. Feel free to develop
the composition beyond the book. Work with similar hues for
harmony or contrasting colors for a more dramatic effect.

A study of branches using watercolors.

***Exercise:* Branching Leaves**

Using colored pens, add veining to these leaves. For inspiration, gather
some leaves outdoors and study their complex branching patterns.

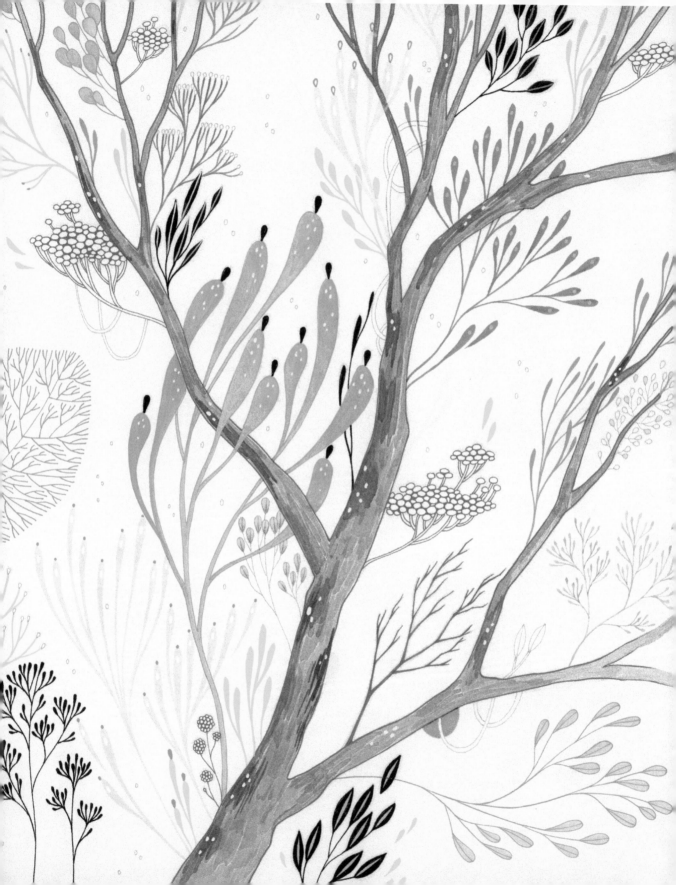

***Exercise:* Finish the Composition**
Complete this drawing by adding as many different types of
branches as you can think of. Try to unify the design with color
and movement by continuing the same rhythm of elements.

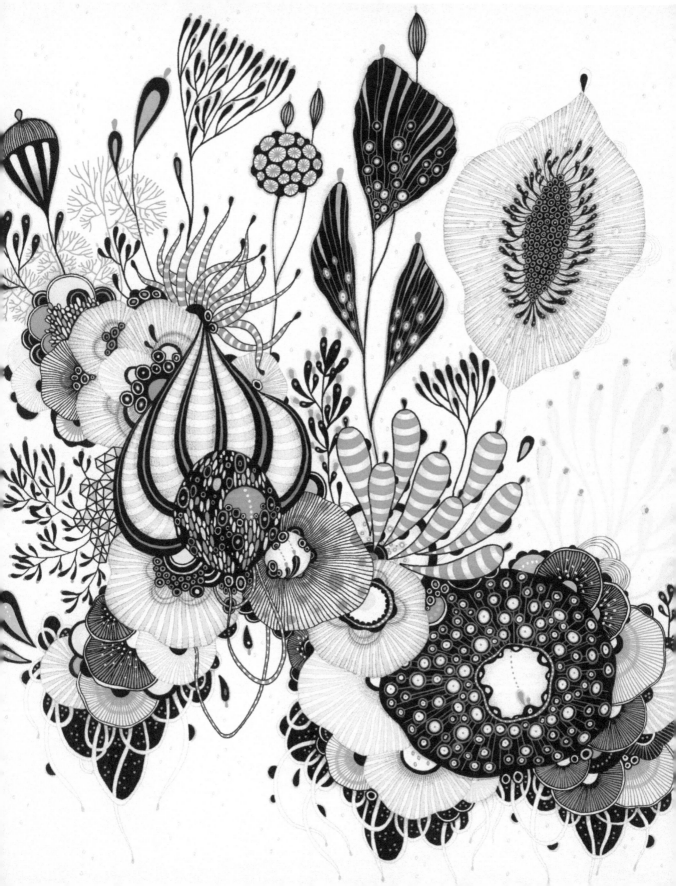

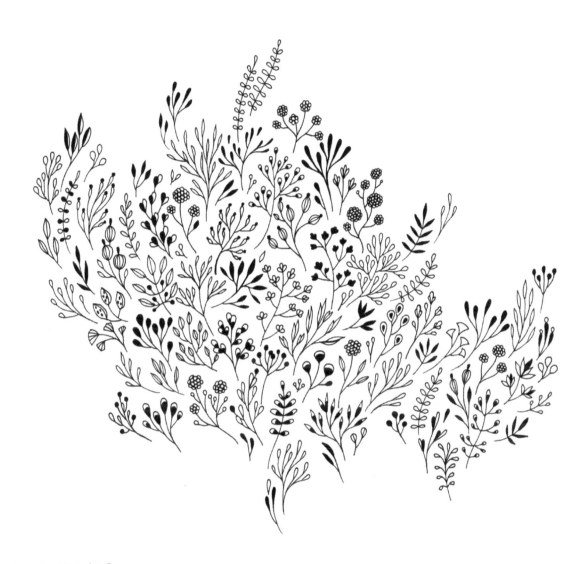

Exercise: Negative Space

Use a 0.30 mm pen to finish this pattern. Add branches in between while leaving the same amount of negative space. As you work, look at your drawing from a greater distance—this way, you will notice whether the negative space is uniform throughout and if the pattern looks unified.

◄ *Cheer.* Pen and watercolor on paper.

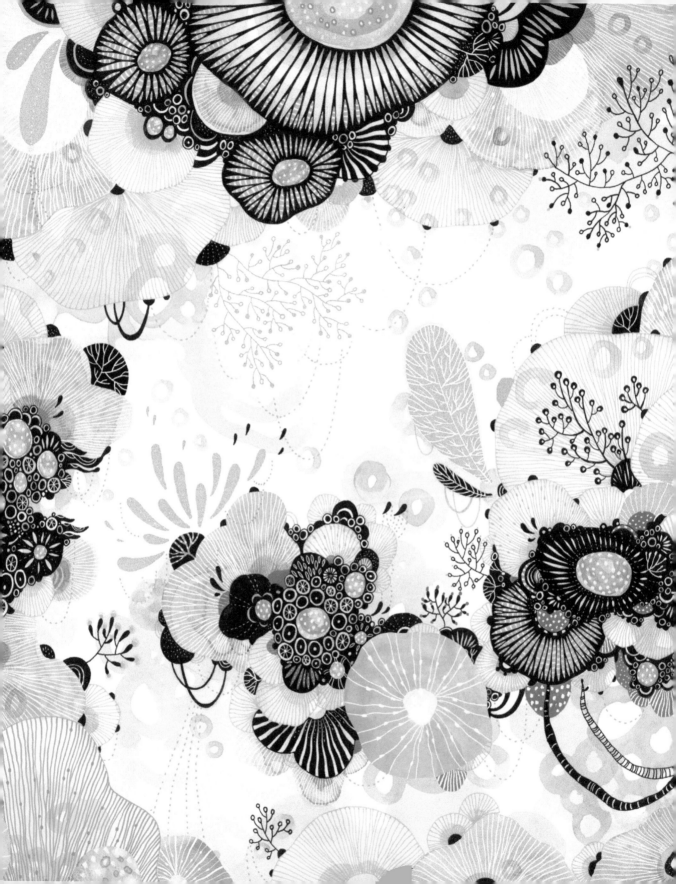

4
THE SPIRAL

The spiral is associated with life energy. It appears in our DNA, on our fingertips, and in our hair follicle growth patterns. The cochleae inside our ears, which give us the ability to balance, are spiral shapes that follow the divine proportion. Energy moves through air and water in spirals, as noticed in smoke trails, waves, and water being pulled down a drain. It's an energy that is a part of us and that we are a part of. It is gravity and momentum, as our galaxy moves us along on a spiraling course.

◄ *Blue Amble.* Pen and watercolor on panel. Notice how the elements in this design curl outward from the center in a spiral form to give the piece movement and depth.

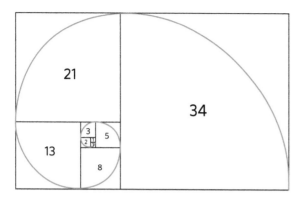

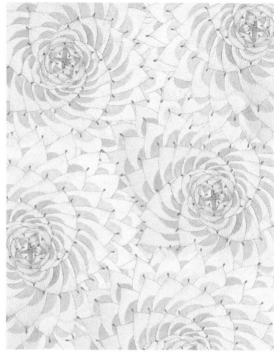

▲ These squares are made using the Fibonacci sequence.

▶ Here is a pattern I made using an *Aloe polyphylla* illustration that blends spiral and star shapes. The plant's spiral form gives the illusion of movement. You can almost feel it spinning.

Types of Spirals

A surprising number of spirals are found in nature. They have names, such as hyperbolic, parabolic, Euler, lituus, and spiral of Theodorus (or Pythagorean). One of the most interesting is a logarithmic spiral called the golden ratio, though you may know it as the Fibonacci sequence, phi, divine proportion, or the golden section. The ratio in this spiral is commonly found in nature as a balance of 1 to 1.618.

The Fibonacci sequence was named for Italian mathematician Leonardo Bonacci (ca. 1170–1250), who brought the magical number sequence to Europe's attention in his book *Liber Abaci* in 1202 CE. In this sequence, each number is the sum of the two preceding numbers—1, 1, 2, 3, 5, 8, 13, 21, 34, and so on.

You can find the golden ratio in the spiral of a nautilus shell, in the swirl of a pinecone's scales, the unfurling of ferns, the skin of pineapples, and the floret patterns of Romanesco broccoli. The seed patterns in the center of sunflowers are made up of two Fibonacci spirals growing in opposite directions. This pattern packs the most seeds possible. It's nature's way of utilizing the space most efficiently.

Using the golden ratio in art compositions is an effective way to guide the viewer's eyes toward a focal point, a technique widely used by masters such as

Leonardo da Vinci and Botticelli. But appreciation for the balance of the spiral does not require familiarity with Western mathematics: The same designs show up in prehistoric rock engravings, Celtic art, African art, Japanese gardens, Chinese art, and Arabic ornaments.

Looking at Spirals

We can spot spirals in many natural creations, such as an unfurling fern frond or the radioles of a Christmas tree worm. Cutting a cabbage in half through its equator will reveal the spiraling growth patterns hidden inside. Here are some different types of spirals.

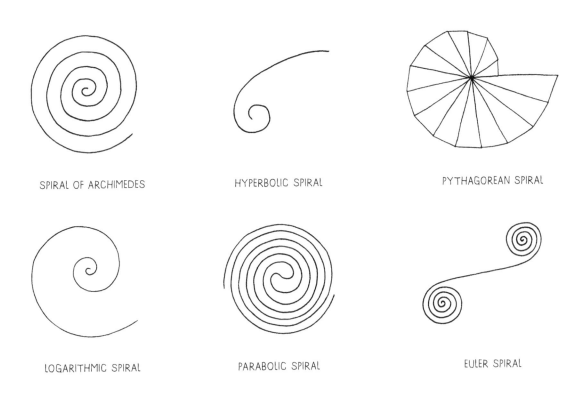

SPIRAL OF ARCHIMEDES

HYPERBOLIC SPIRAL

PYTHAGOREAN SPIRAL

LOGARITHMIC SPIRAL

PARABOLIC SPIRAL

EULER SPIRAL

Exercise: How to Draw a Spiral

Use the pencil guidelines in the drawing opposite to invent your own spiral-shaped plants. Start by adding leaf stems, or midribs. Use a light pencil and make slight marks where the midribs will go. They can curl inward or outward. Think about all of them following the same movement to establish the rhythm of the design.

Pick a leaf shape that you like and add it to your fern. Starting from the center of the spiral or the bottom of the fern will help with the overlapping. Go over your pencil lines with a pen. Use a 0.10 or 0.30 mm pen for fine lines. Once you've completed your ink drawing, erase the pencil lines and add color. Try to make three completely different ferns with differently shaped leaves.

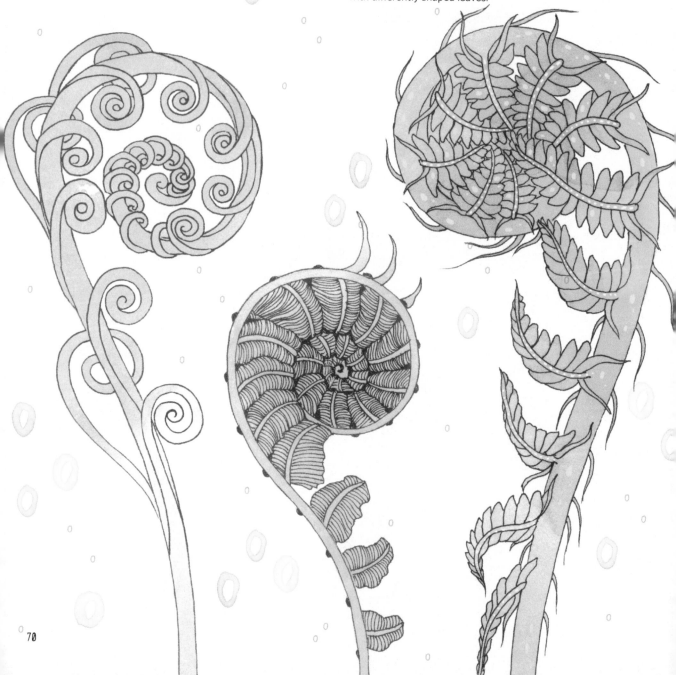

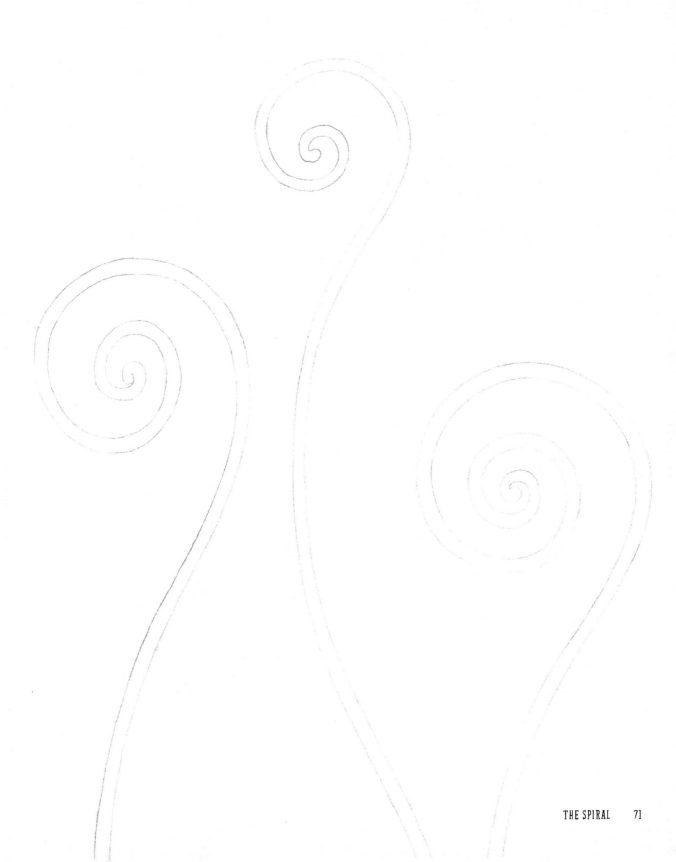

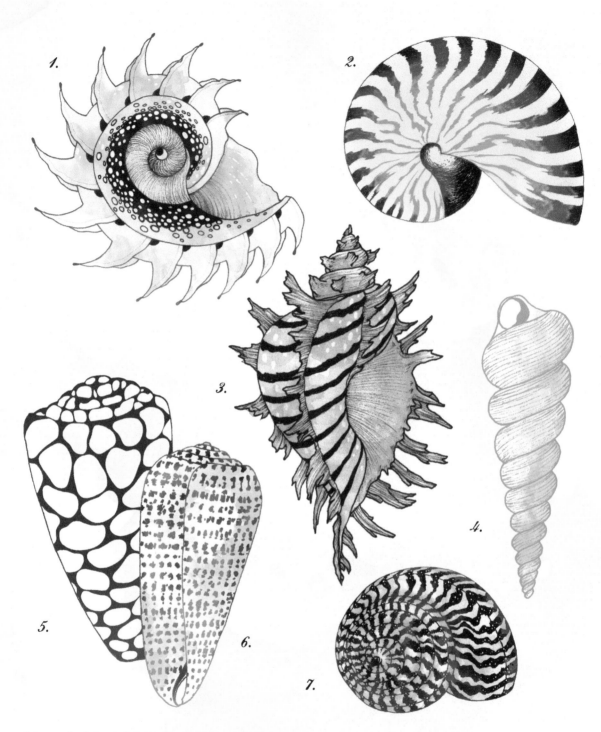

1. Long-spined star shell 2. Nautilus 3. Murex seashell 4. Turritella seashell 5. Marbled cone
6. Alphabet cone 7. Turbinidae shell

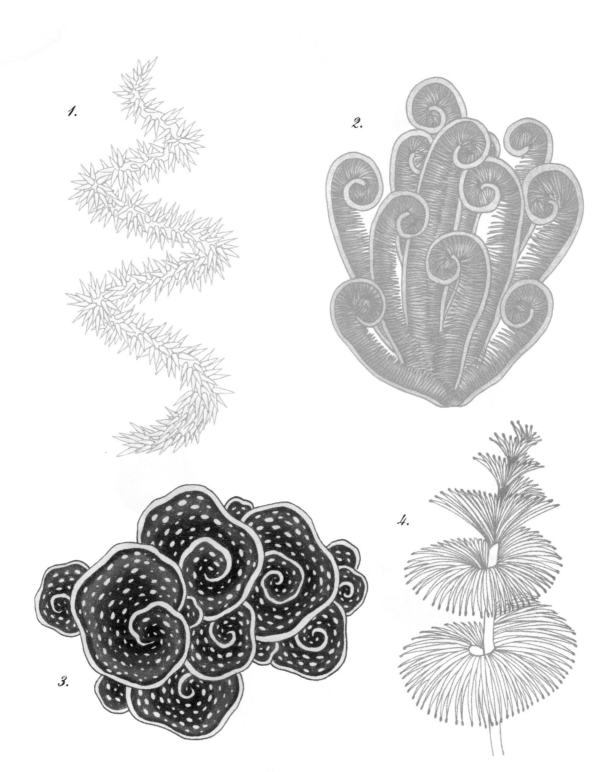

1. Cirrhipathes 2. Feather stars 3. Lettuce coral 4. Christmas tree worm

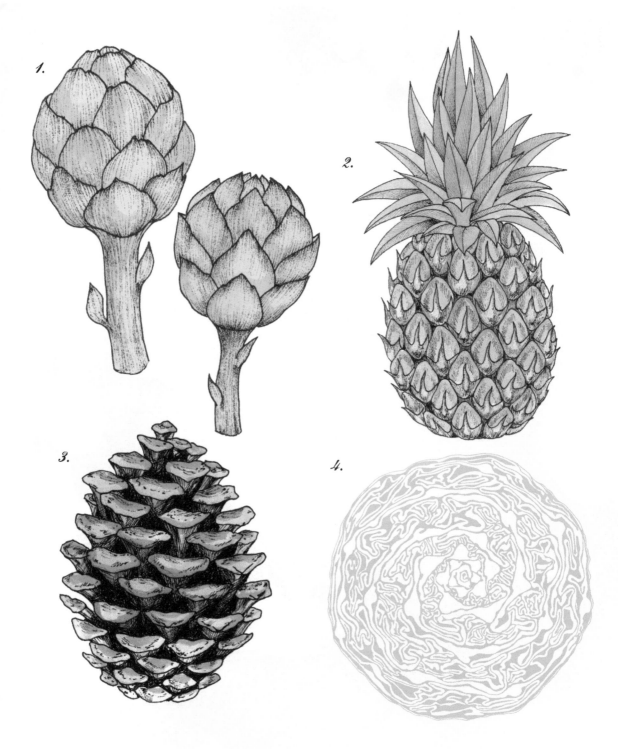

1. Artichoke 2. Pineapple 3. Pinecone 4. Cabbage

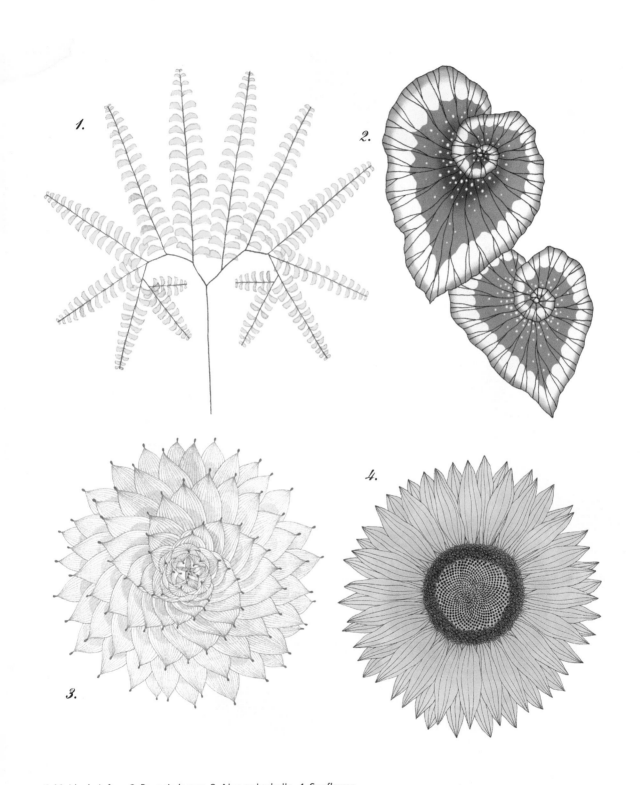

1. *Maidenhair fern* 2. *Begonia leaves* 3. Aloe polyphylla 4. *Sunflower*

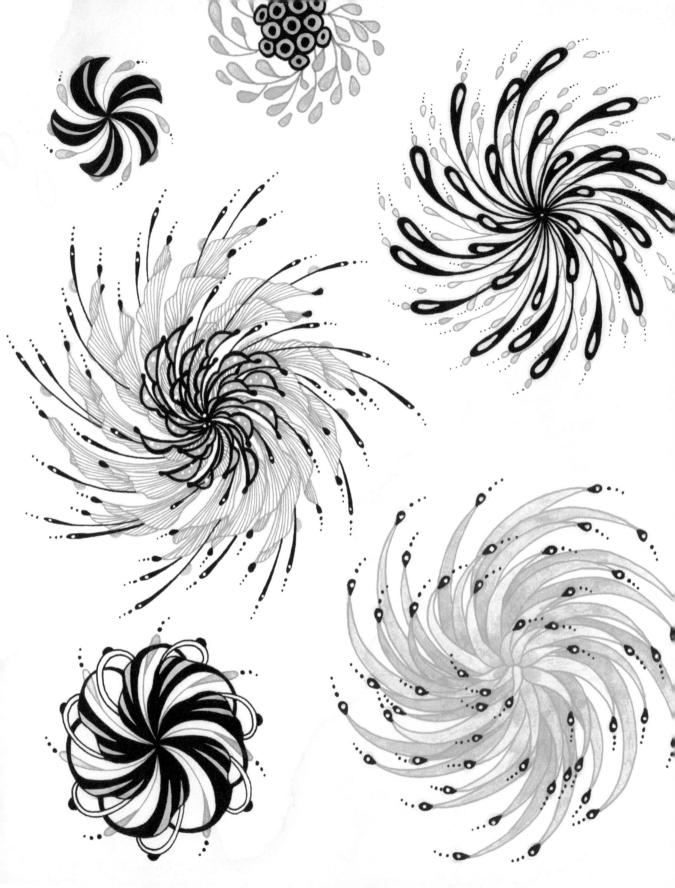

***Exercise:* Abstract Pinwheels**

Try drawing abstract pinwheels. Start by sketching them lightly with a pencil and then go over your lines with a pen. Use pens or watercolors to add color. Make as many different pinwheels as you can, using a similar color palette to unify the design.

◄ Abstract Pinwheels.

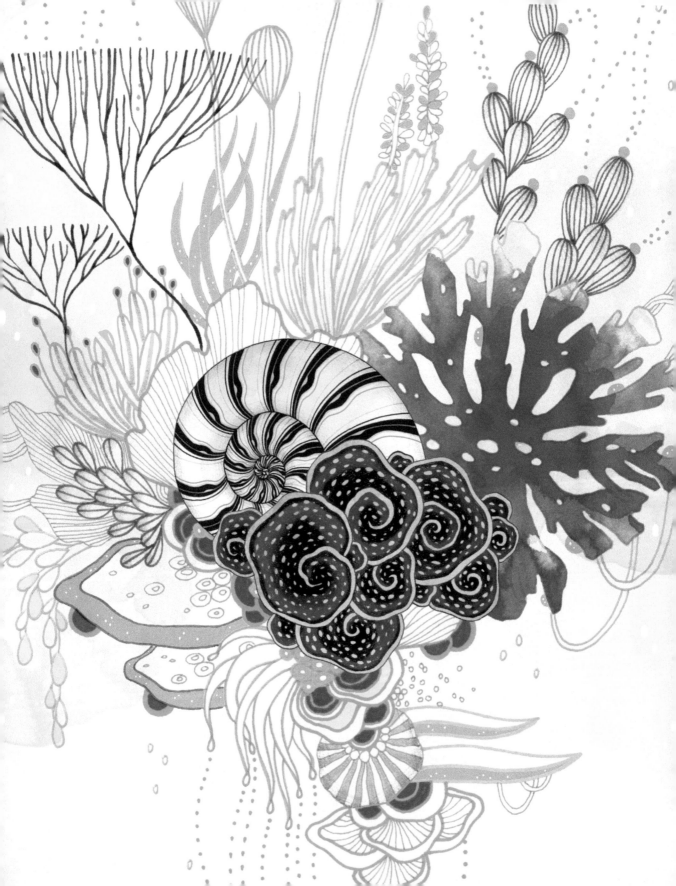

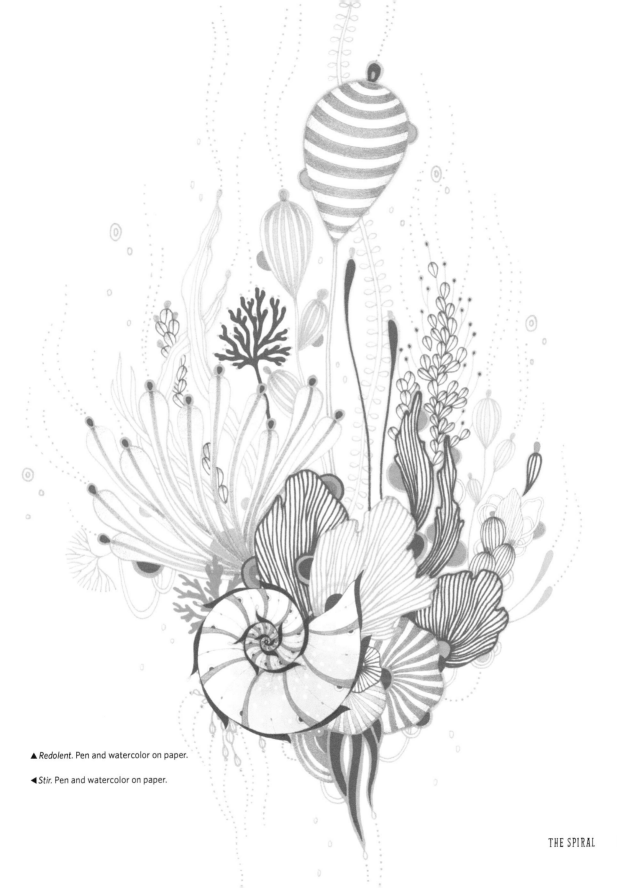

▲ *Redolent*. Pen and watercolor on paper.

◀ *Stir*. Pen and watercolor on paper.

Exercise: **Drawing a Spiral Shell**

Here you'll learn how to use a spiral to draw a shell. Work on the opposite page, following these instructions.

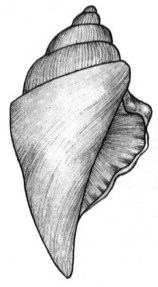

1. Using a light pencil, draw a spiral.

2. Connect the open sides of the spiral to create overlapping ovals. Add the bottom of the shell and the shell's opening.

3. With a pen, go over the pencil drawing to define the shape of the shell.

4. Erase the pencil drawing to reveal the shell.

5. Add shading, using pen or pencil, to define the shell form.

6. Add color to your shell with colored pencils or watercolors.

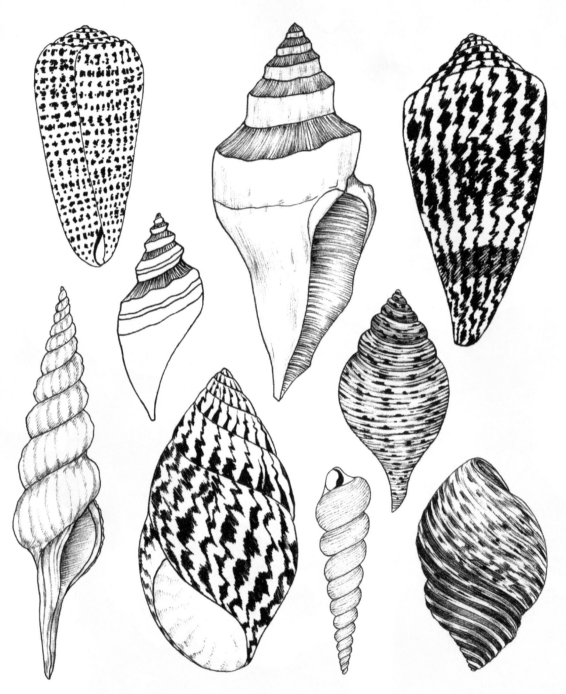

Exercise: **Adding Color**
Add color to these shells using watercolors, colored pencils, or pens. Add shading and think about balancing colors on the page.

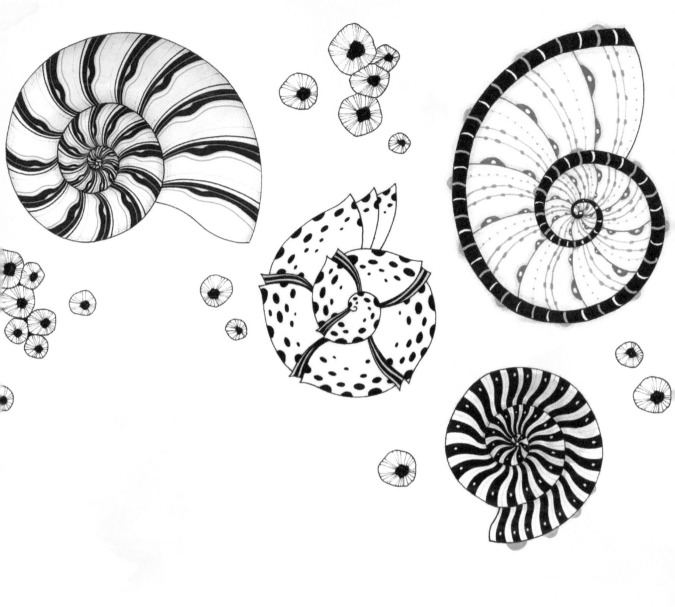

***Exercise:* Pattern Inspiration**
Add spiral-shaped shells to this composition. Look at photos of
actual shells for pattern inspiration. Make the shells different
sizes to add variety to the drawing.

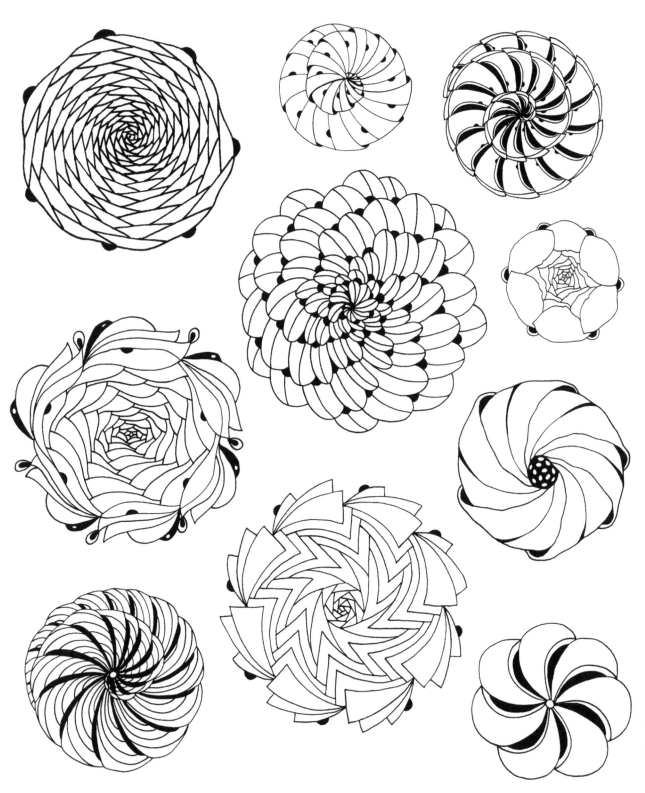

Exercise: Floral Spiral Ornaments

Create floral ornaments inspired by spirals. Start with a pencil
sketch or draw directly with a pen. Feel free to add details and
color to your ornaments once you're done with the pen work.

◀ Floral Spiral Ornaments.

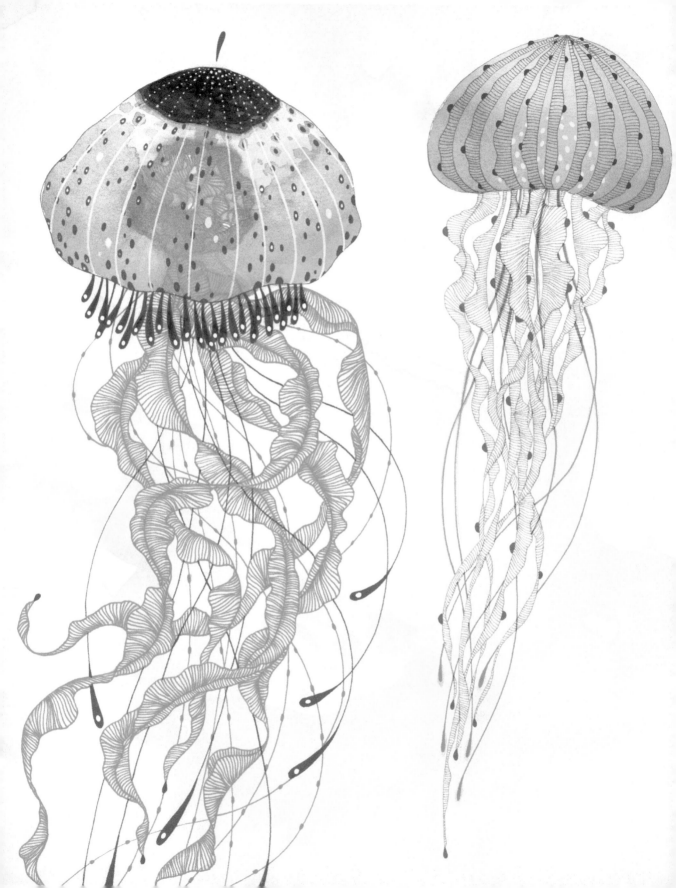

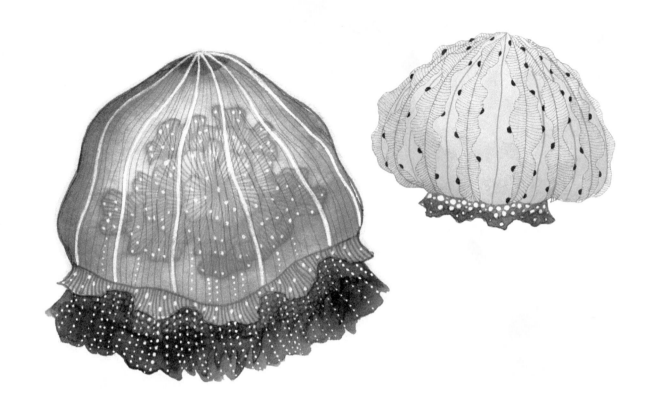

***Exercise:* Adding Spirals to Jellyfish**

Add spiral tentacles to the jellyfish. Think about the movement
and how the tentacles twist in a spiral form. A fine-tip pen will
provide the best results. All the tentacles should follow the same
movement and be fluid and curvy to look like they're floating.

Exercise: **Finish the Composition**

Finish this composition using a 0.20 or 0.30 mm pen. Add
elements in a spiral form around the existing drawing, extending
them onto this page. Sketch the composition with a light
pencil before developing your drawing. Use different shades of
watercolors before adding pen work on top.

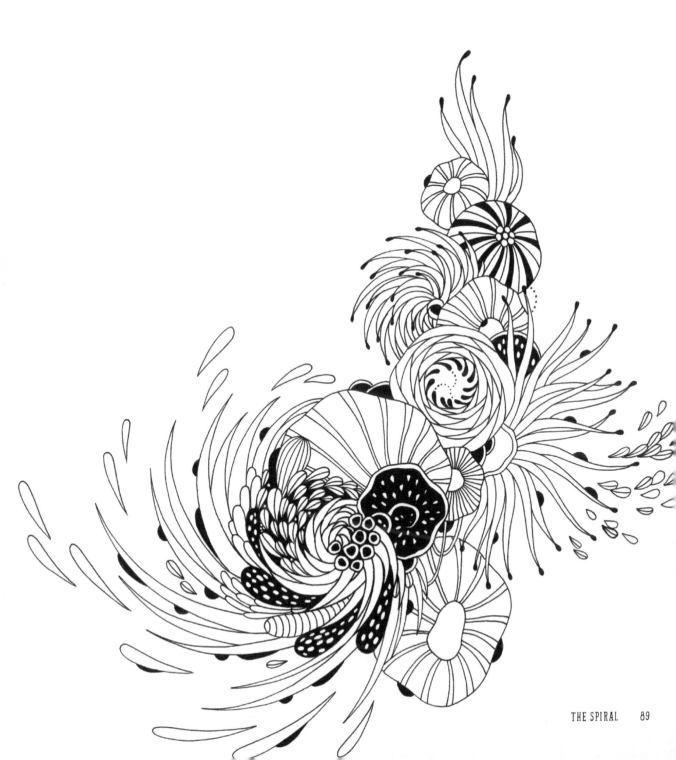

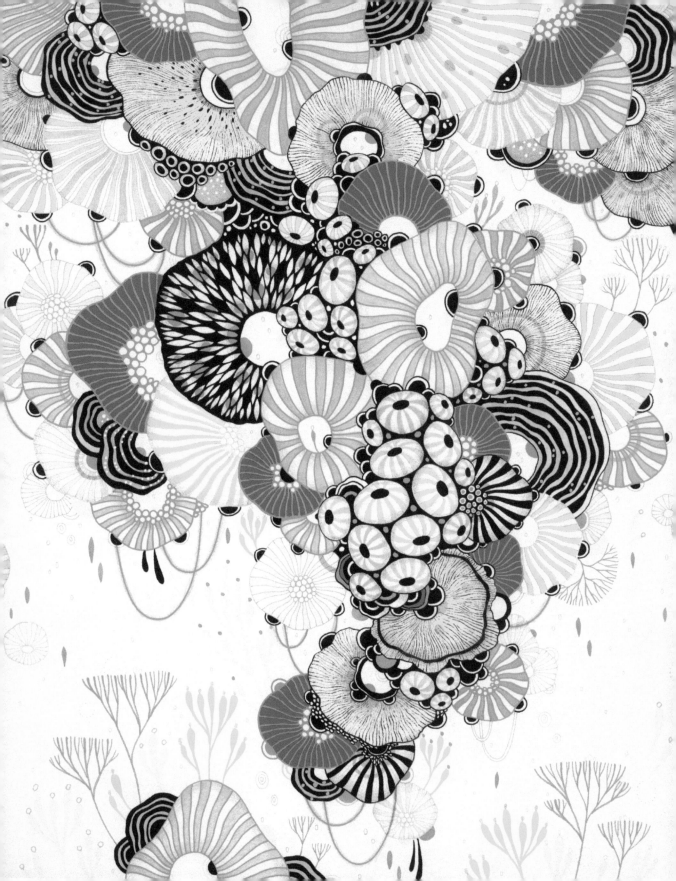

5

THE FAN

The fan is a versatile shape, both in nature and in design. It can be defined as a series of repeating lines, line segments, planes, or shapes that meet at one end. In nature, the fan shape is most often used to harness and disperse energy. A bird's wing is perfectly evolved to use the energy in air for creating lift and thrust. Fish fins are used in a similar fashion in the water. Puffer fish use their fan-shaped fins to make circular sandcastles by creating water current and directing it toward the sand below. Nature gave maple tree seeds fan-shaped wings that enable them to travel great distances in a moderate wind. Humans have borrowed from nature's fan design to create windmills, propellers, and turbines that convert wind into energy. The practice of borrowing from nature's design in manmade technology is called "biomimicry."

In design, fan shapes can be used to give balance because they are heavier on one side than the other. Or they can be used for emphasis and as a focal point of a piece. Their expanding shape can help fill in large areas and direct the viewer's eye. The fan shape is also terrific for making patterns, which we will cover later in this chapter.

Looking at Fans

Following are illustrations of some of the fan shapes found in nature. The leaves of the gingko biloba plant, the gills of several fungi, and the shells of scallops are all fan shaped. Fans can be straight and rigid, like the fronds of palms, or wavy and flowing, like fish fins.

◄ *Fervor.* Pen and watercolor on paper.

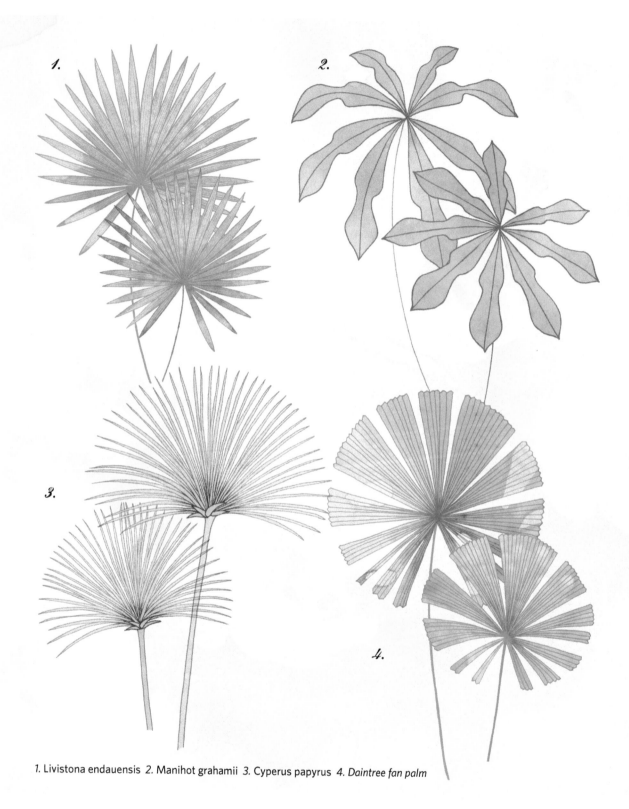

1. Livistona endauensis 2. Manihot grahamii 3. Cyperus papyrus 4. Daintree fan palm

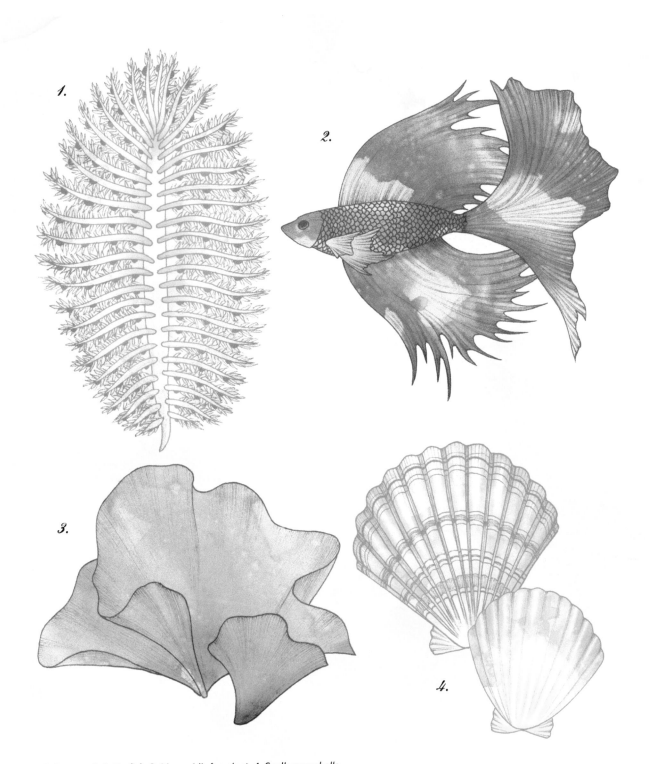

1. Sea pen 2. Betta fish 3. Mermaid's fan plant 4. Scallop seashells

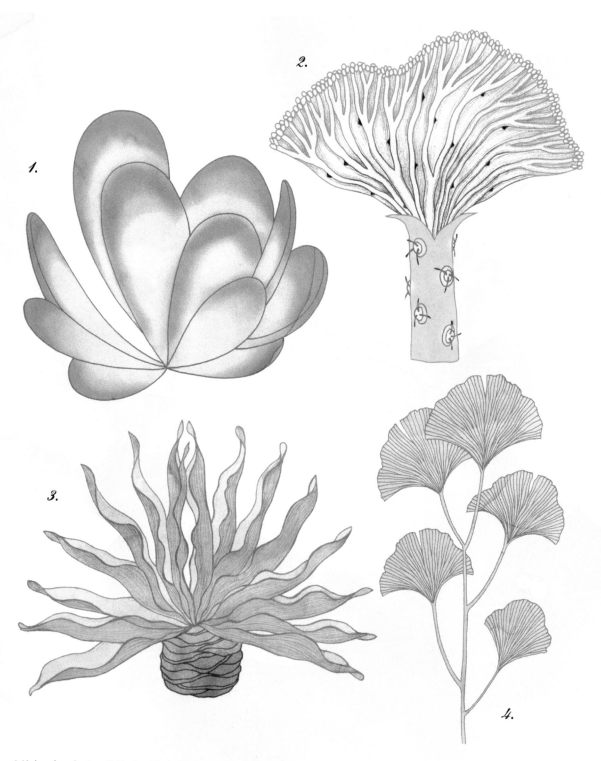

1. Kalanchoe luciae 2. Euphorbia lactea 3. Boophone 4. Ginkgo biloba

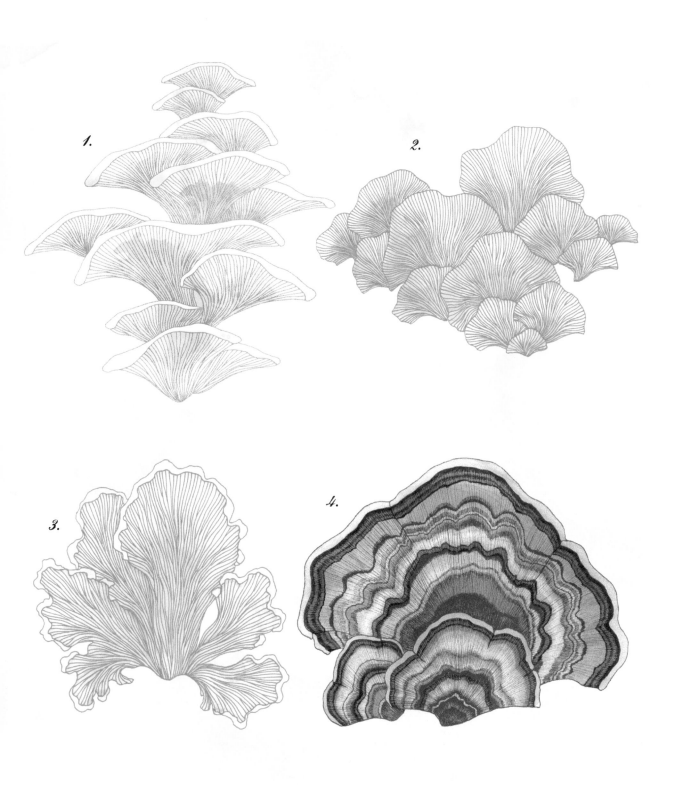

1. Oyster mushrooms 2. Panellus stipticus 3. Schizophyllum 4. Turkey tail

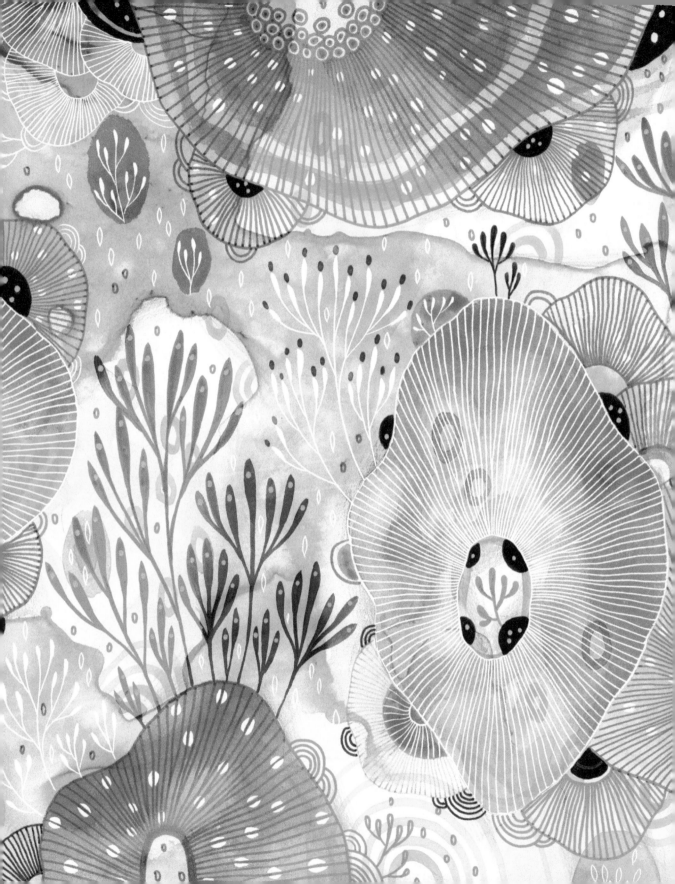

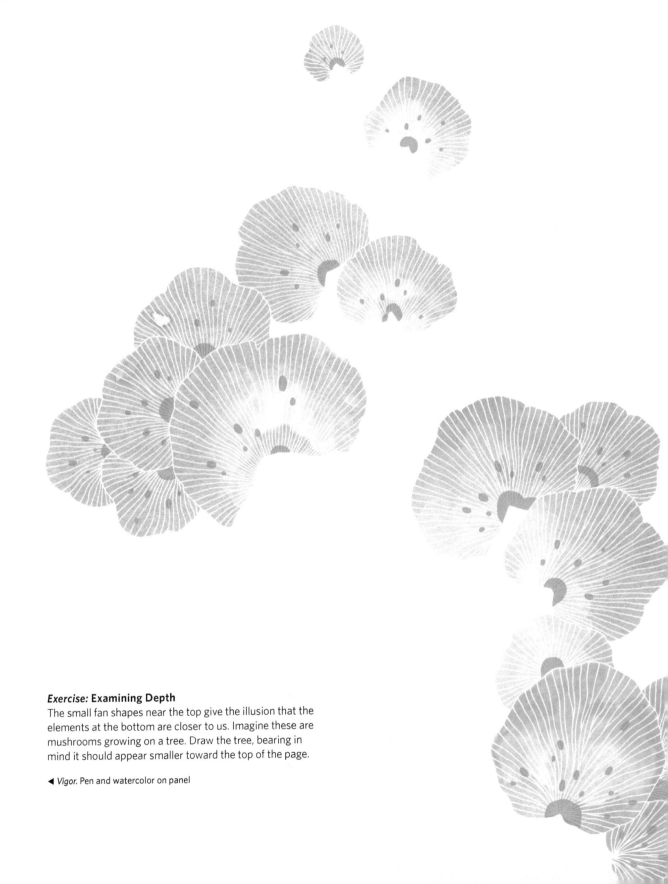

Exercise: **Examining Depth**

The small fan shapes near the top give the illusion that the
elements at the bottom are closer to us. Imagine these are
mushrooms growing on a tree. Draw the tree, bearing in
mind it should appear smaller toward the top of the page.

◄ *Vigor.* Pen and watercolor on panel

Exercise: **Evolving the Fan Shape**

For this exercise, we'll use a simple fan shape and help it evolve into a more complex element.
Work on the opposite page, following these instructions.

1. Begin by drawing a simple fan-shaped element.

2. Draw another shape based on the one you just drew, but add slight changes, such as curves or pointy lines.

3. Draw the same shape again but add movement to it. Make it sway to the right or left. Think about spreading it or constricting it. Make it look alive.

4. Redraw the last shape and add more detail to it. Think about connecting some parts to make a fuller shape and exaggerating some parts to better define the shape.

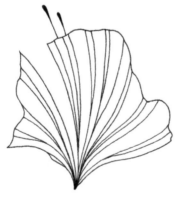

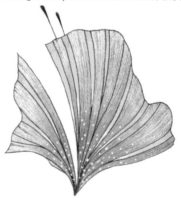

5. Go over your pencil drawing with a pen and then erase the pencil marks.

6. Use watercolors or colored pencils for coloring and gel pens or gouache for adding opaque details on top.

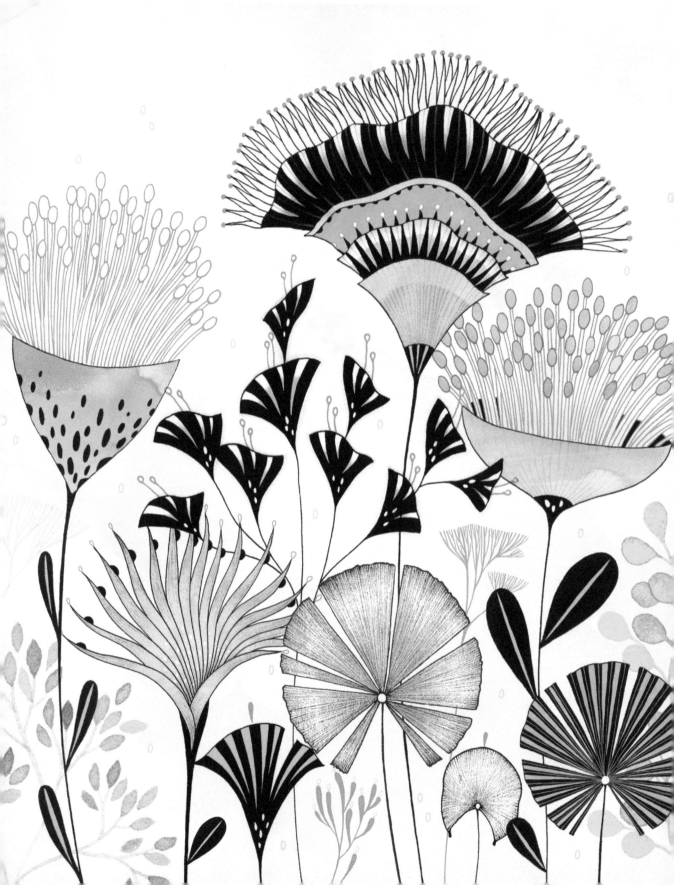

Exercise: Drawing Fan-Shaped Plants

Create your own fan-shaped plants by pencil sketching them before going over them with a pen. Think about variety in shape, color, and size in your composition. Add branches or other plants in between. Think about using the same color in more than one area for balance.

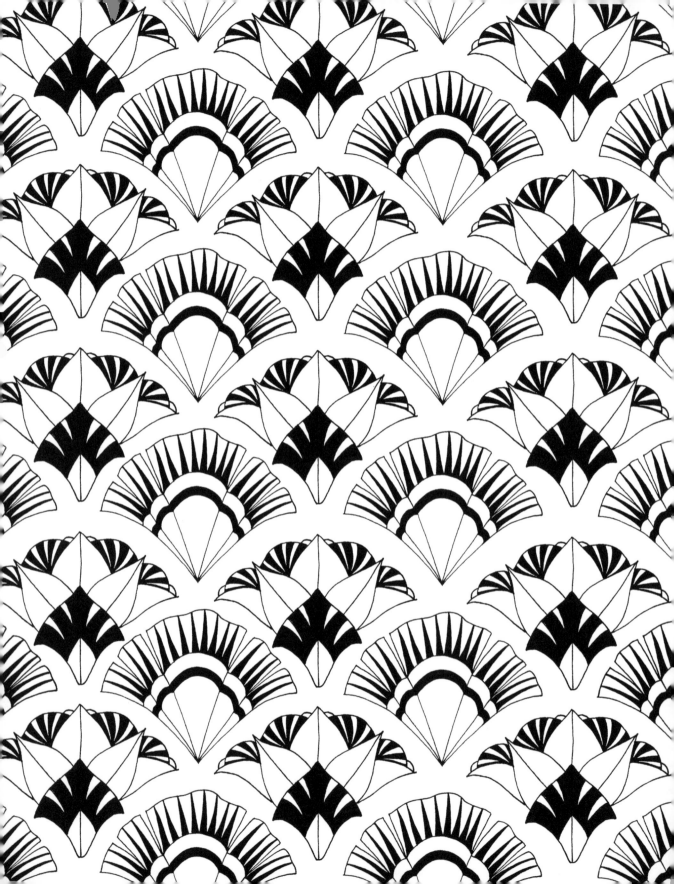

Exercise: Creating a Fan Motif Pattern

Fans can be used for creating easy patterns. Draw some fan motifs in black and white. Use a pencil outline as a guide for your motifs. Finish your designs with a pen and fill in some parts for contrast and a more graphic look.

Exercise: **Creating a Fan-Shape Repeating Pattern**

In this exercise, you'll make a fan shape that will tile perfectly in a half-drop repeating pattern. You'll need a compass and a right angle. Work on the opposite page, following these instructions.

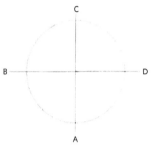

1. Use a compass to draw a circle. Divide the circle into four equal parts using a right angle. Mark the intersecting points A, B, C, and D.

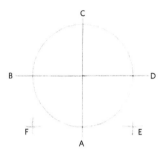

2. With the same opening on the compass, make intersecting marks outside the circle with the needle on point D and then on point A. Repeat the same process with points A and B. Mark the new spots E and F.

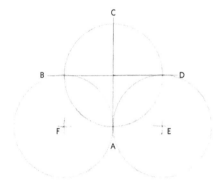

3. Make a new circle with the compass needle on point E and then another circle with the needle on point F.

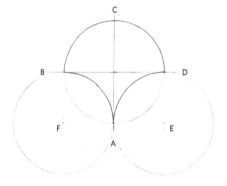

4. The intersecting circles form a fan shape. Mark the outline of your fan with a pen.

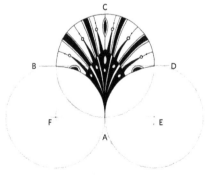

5. Draw a design within the fan shape. It helps to work with a pencil first and then go over it with pen.

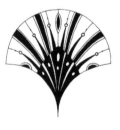

6. When you are done with your design, erase the pencil marks. You now have a shape that will tile perfectly to make a seamless pattern like the one on the next page.

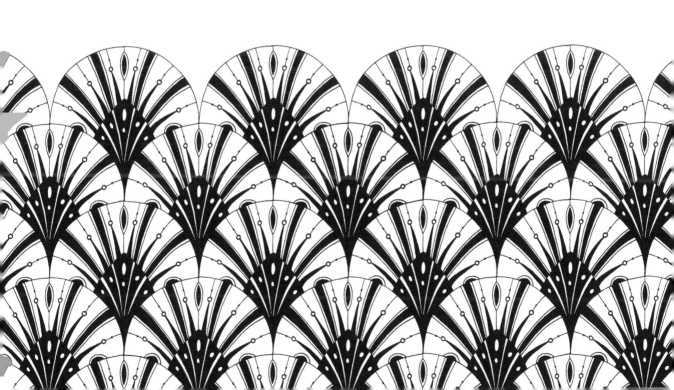

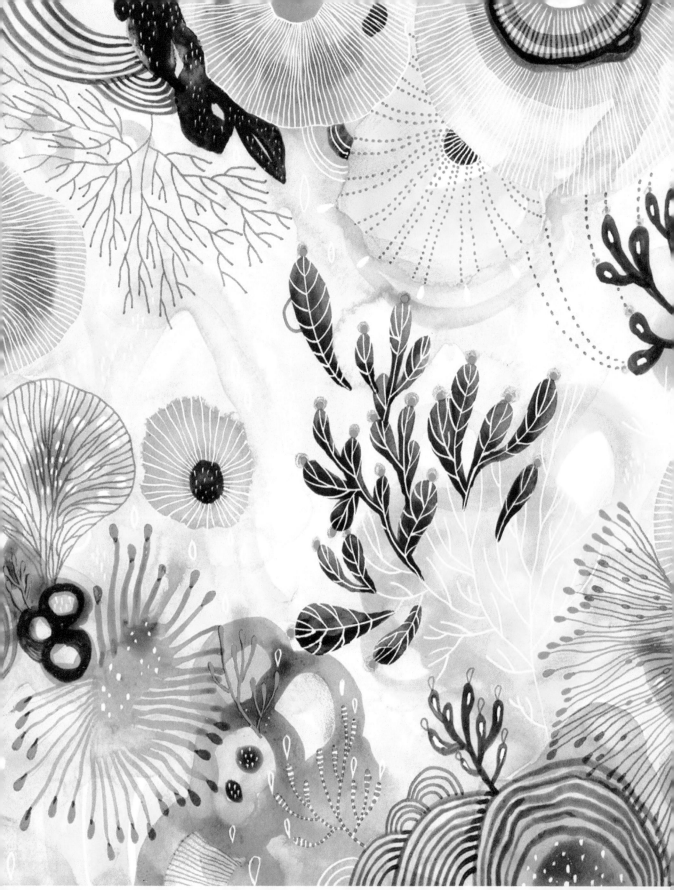

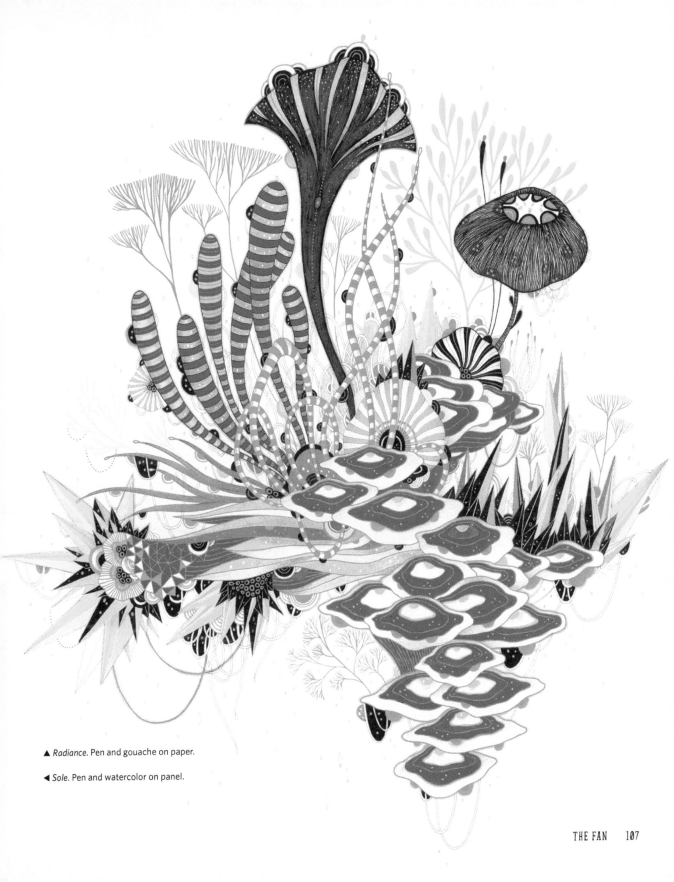

▲ *Radiance*. Pen and gouache on paper.

◄ *Sole*. Pen and watercolor on panel.

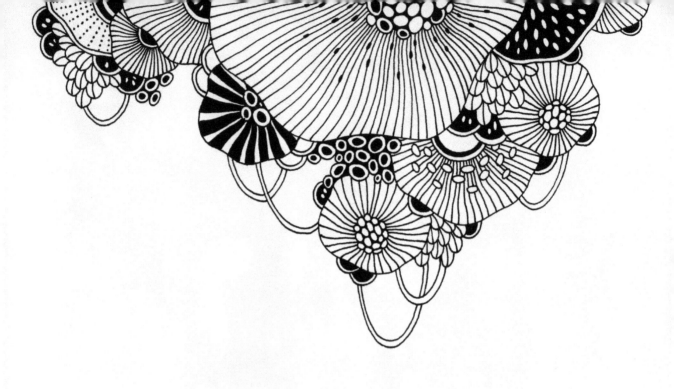

Exercise: Adding Fan Shapes

Add fan shapes to this composition. Try adding elements on top
of one another to follow the rhythm of the drawing. Leave some
areas sparsely filled to create negative space. Either make two
separate works or one piece by finding a way to connect the
elements on the two pages.

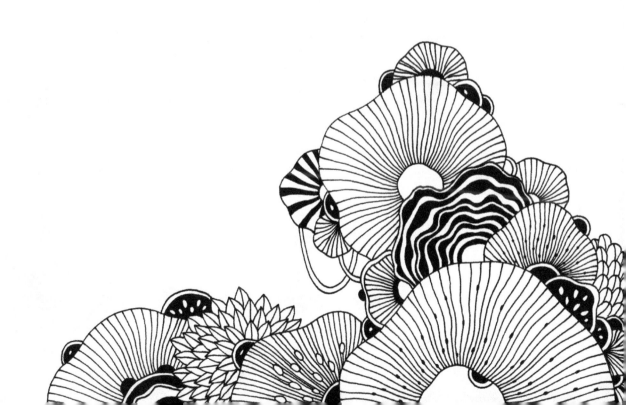

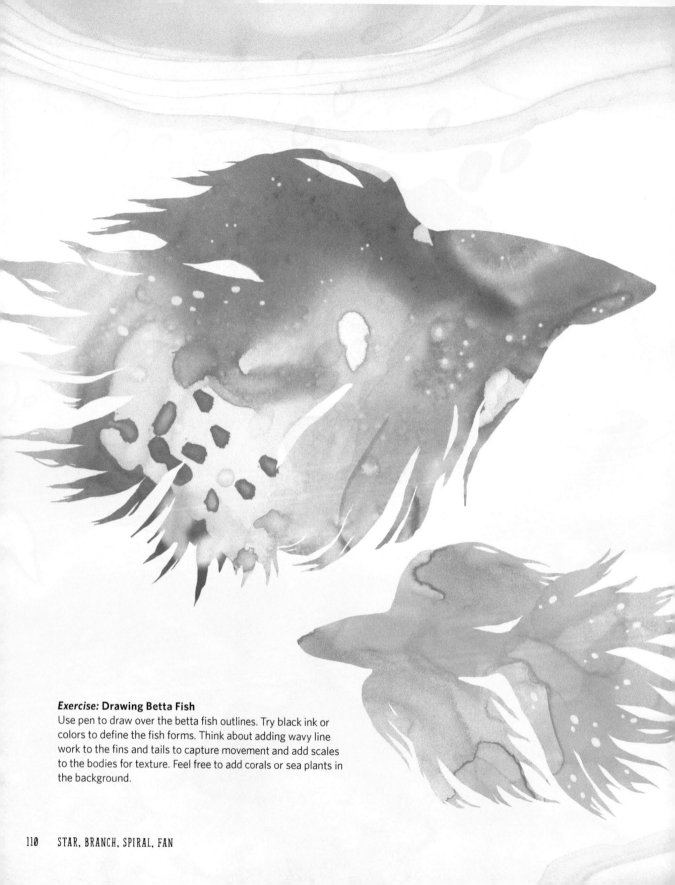

***Exercise:* Drawing Betta Fish**
Use pen to draw over the betta fish outlines. Try black ink or
colors to define the fish forms. Think about adding wavy line
work to the fins and tails to capture movement and add scales
to the bodies for texture. Feel free to add corals or sea plants in
the background.

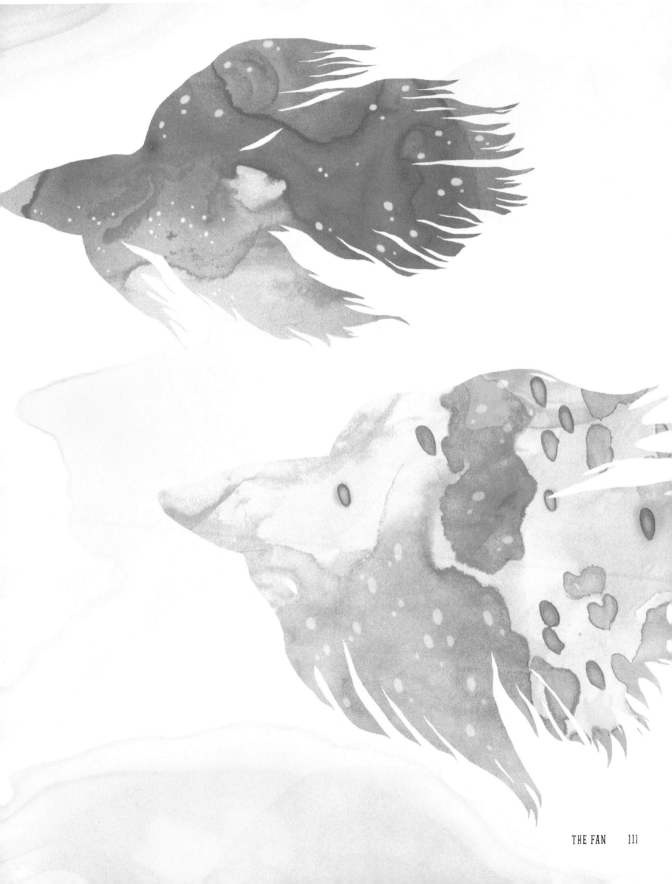

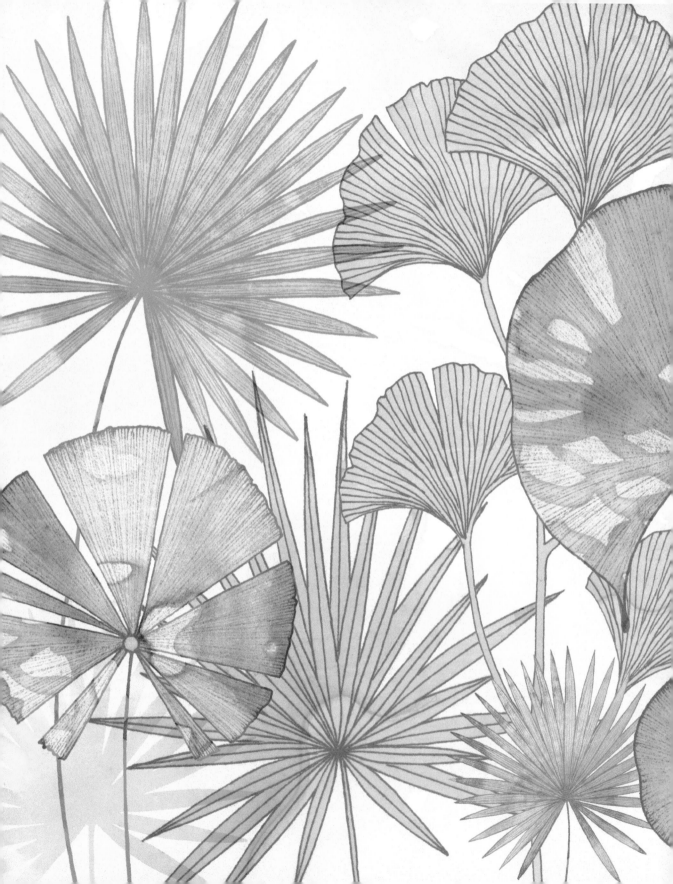

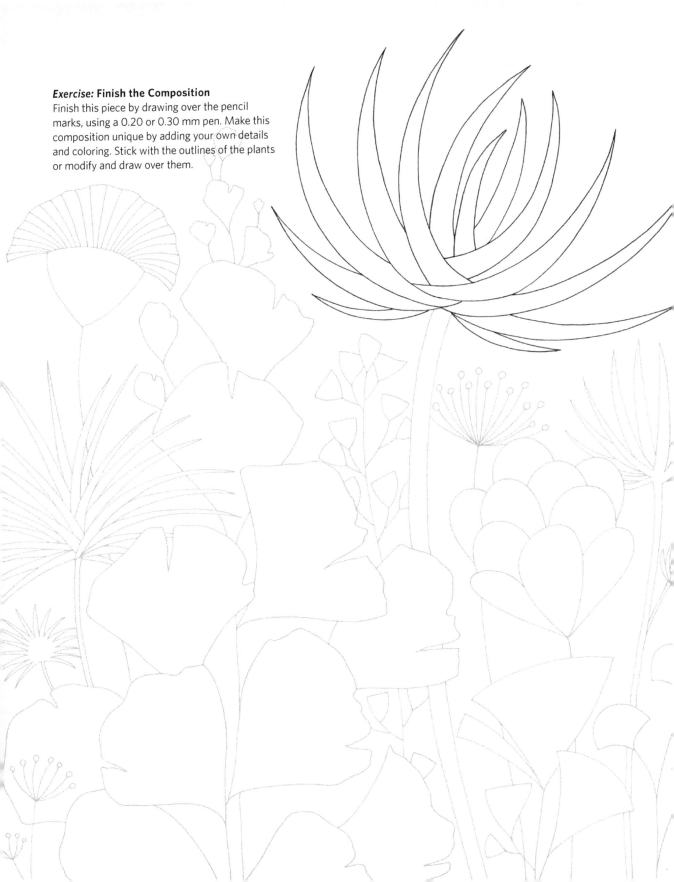

Exercise: Finish the Composition
Finish this piece by drawing over the pencil
marks, using a 0.20 or 0.30 mm pen. Make this
composition unique by adding your own details
and coloring. Stick with the outlines of the plants
or modify and draw over them.

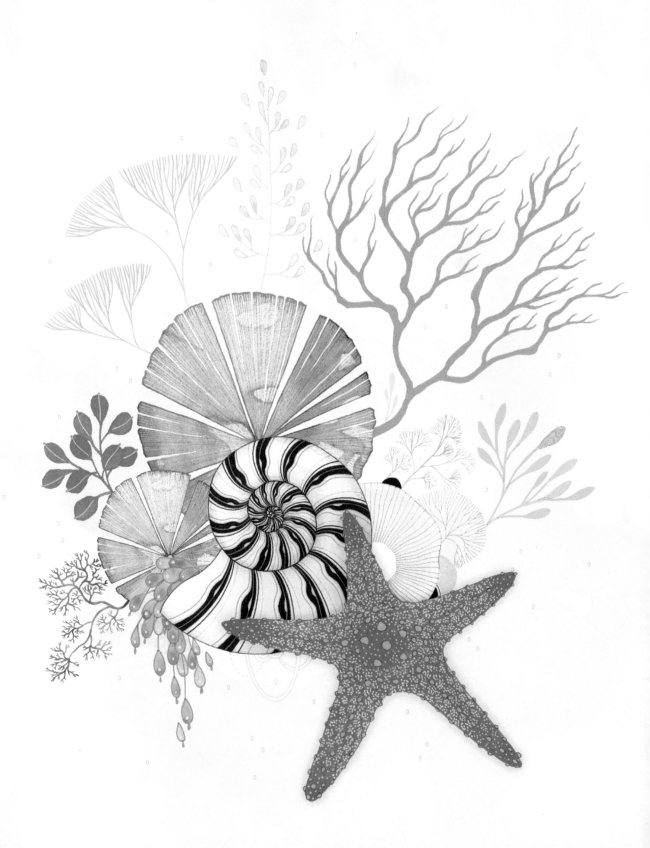

6
PUTTING IT ALL TOGETHER

In the following pages, we'll work together to create designs using the four elements explored in this book—the star, branch, spiral, and fan. I'll get you started with a design that just needs color. Next, I've included drawings in various stages of completion. I left most of the lines faded so you can draw over them and expand the design. Feel free to modify and add color to each of the designs using your favorite pens, pencils, or paints.

As you work, refer back to the elements and principles of design (see pages 10–13) from time to time, as well as the many different techniques we've practiced in this book. Don't be afraid of mistakes, and, above all, enjoy the process. If you are ever in need of inspiration, just look to nature—the greatest designer of all.

◀ Stars, branches, spirals, and fans.

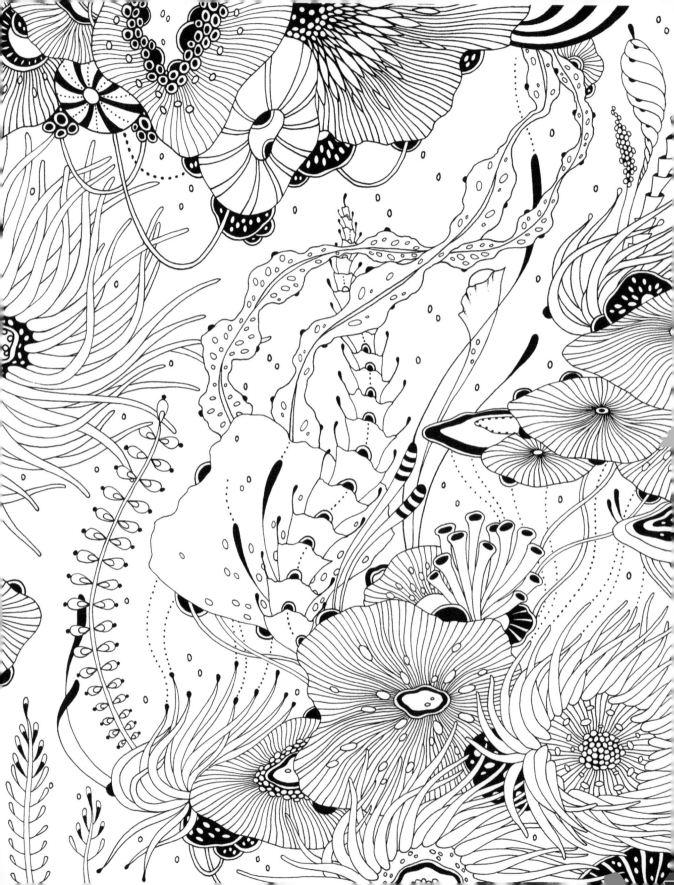

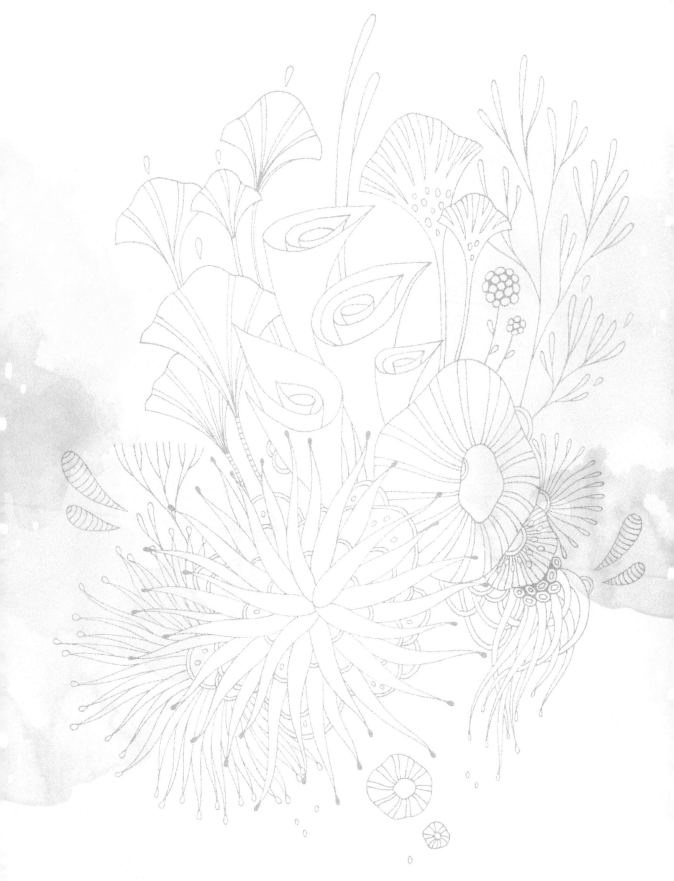

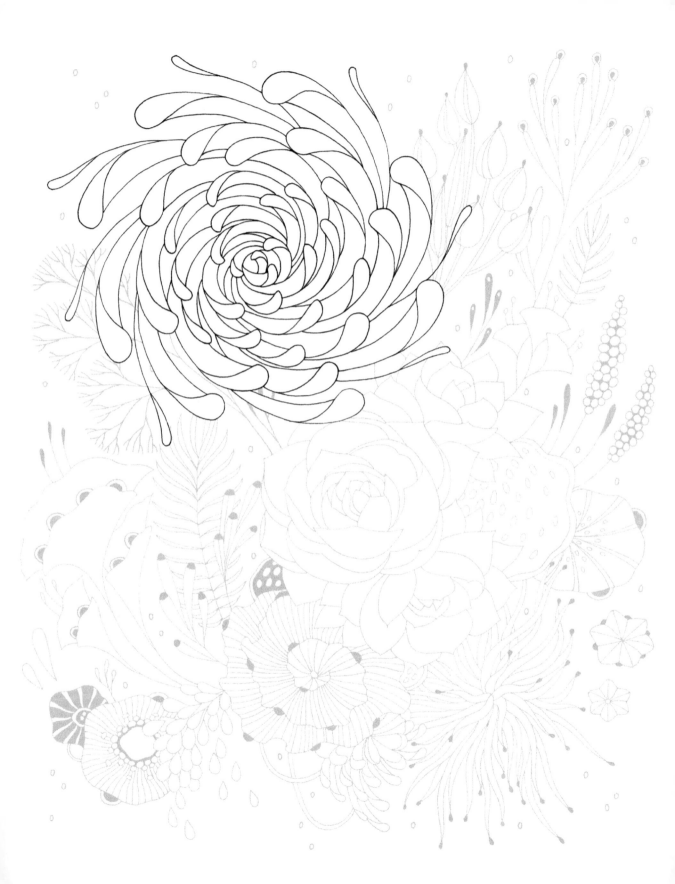

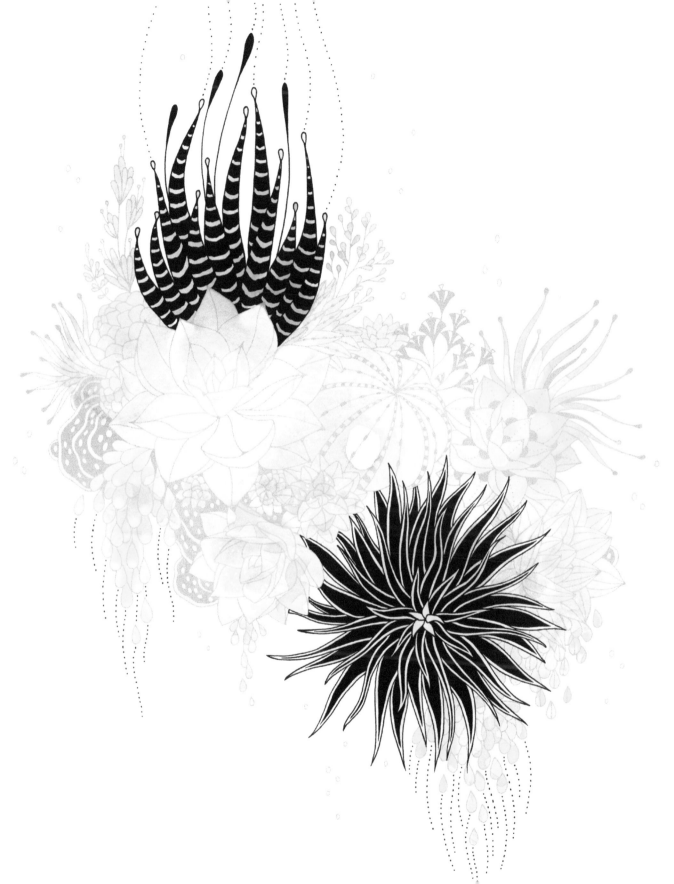

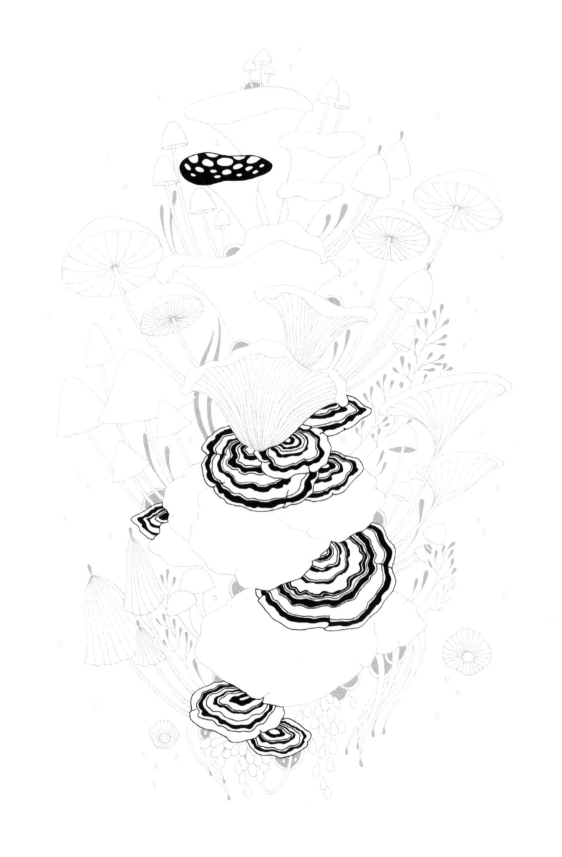

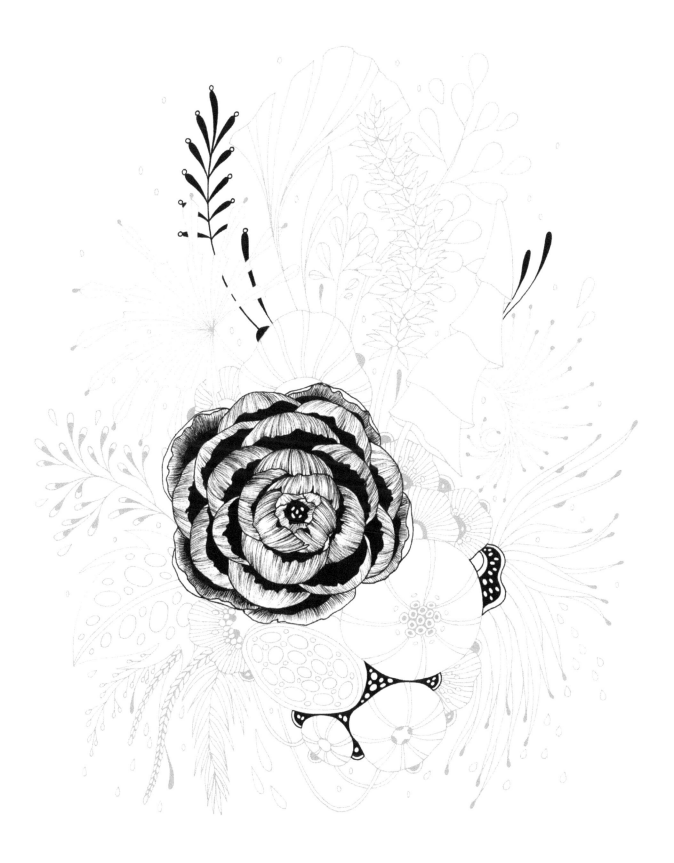

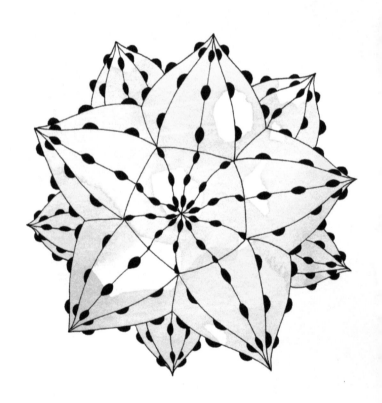

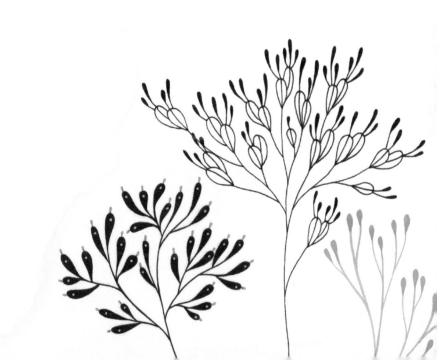

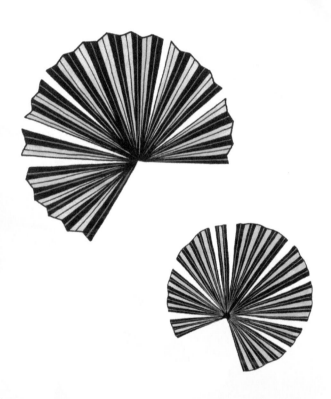

Resources

PENS AND ART MATERIALS

Blick art materials: www.dickblick.com
Micron pens: www.pigmamicron.com
Prismacolor pens and color pencils: www.prismacolor.com
Staedtler pens: www.staedtler.com

INKS, ACRYLICS, AND WATERCOLOR

Bombay India inks: www.docmartins.com
FW inks by Daler Rowney: www.daler-rowney.com
Golden acrylics: www.goldenpaints.com
Rapidographs: www.kohinoorusa.com
Winsor & Newton watercolors: www.winsornewton.com

Acknowledgments

I would like to thank Judith Cressy, my editor, who entrusted me with her idea for this book, for her wonderful encouragement and guidance, and for making everything so easy for me. To Heather Godin, for her art direction and creative input, and for being open to all of my ideas. To the rest of the team at Rockport Publishers who helped make this book, including Cara Connors, project manager, and Debbie Berne, layout designer.

Thank you to my mom, dad, and sister for their constant love and support.

To Peg and Steve for always being there. And a big heartfelt thanks to the rest of my family and friends.

Thanks to all of the curators and gallery owners who have shown my work, starting with Eric Nakamura for giving me my first-ever solo show at the Giant Robot.

To all of the art collectors and fans whose support has changed my life in immeasurable ways. All of the teachers who have shared my work with their students and who dedicate their time to the arts.

Thank you, as well, to all of the artists who are out there working to realize their own unique vision and daring to share it with the world.

And most of all, to my Andrew. We did it; we made a book.

Vital. Acrylic on panel. ▶

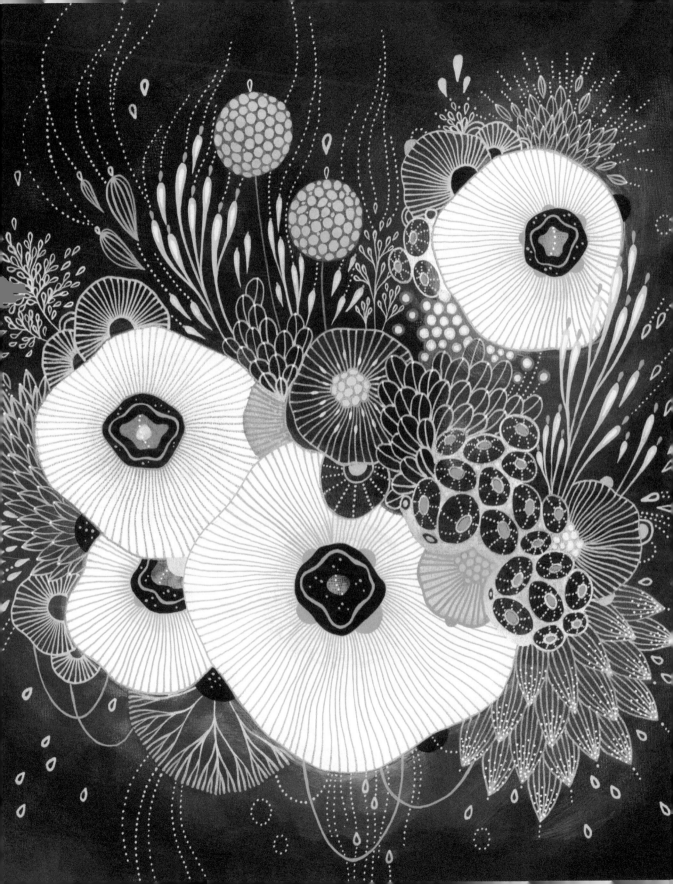

About the Author

Originally from Sarajevo, Yellena James is an artist and illustrator who lives and works in Portland, Oregon. James' work explores the intricate and delicate forms of an imagined ecosystem, inventing flora and fauna that twist and float together in a magical dreamscape. Preferring pens, watercolors, and acrylics, she combines colorful arrangements of animate shapes and tangled lines that are at once floral and alien, organic and sci-fi. Each piece she creates is a glimpse into an intimate world that possesses its own ethos and radiates its own emotional range.

James has participated in shows around the United States and overseas, including solo exhibitions at Giant Robot (San Francisco and Los Angeles), the Here Gallery (Bristol, UK), the Hijinks Gallery (San Francisco), LeQuiVive Gallery (Oakland, CA), and more. She also has done illustration work for Anthropologie, La Mer, Crabtree and Evelyn, Crate and Barrel, Relativity Media, and many others. For more information, visit www.yellena.com.

CPSIA information can be obtained
at www.ICGtesting.com
Printed in the USA
LVHW071103120920
665588LV00003B/3